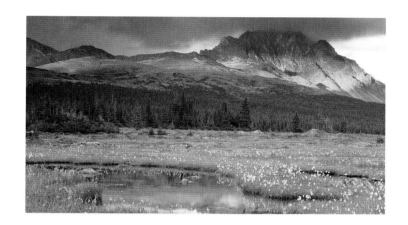

ALBERTA

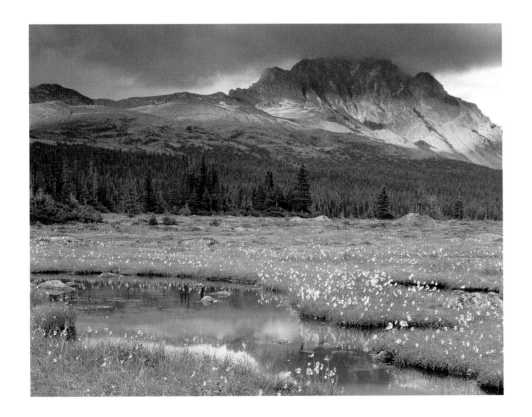

PROSPERO
B·O·O·K·S
A DIVISION OF CHAPTERS INC.

This edition produced for Prospero Books,
a division of Chapters Inc.
by Whitecap Books Ltd.
Vancouver / Toronto

Cover and book design by Steve Penner
Cover photograph by Darwin Wiggett / First Light
Text by Tanya Lloyd
Edited by Elaine Jones
Proofread by Elizabeth McLean
Photo editing by Pat Crowe

Printed and bound in Canada by Friesens, Altona, Manitoba.

Canadian Cataloguing in Publication Data
Lloyd, Tanya, 1973-
Alberta

ISBN 1-55110-529-2

1. Alberta--Pictorial works. I. Title. II. Series:
Lloyd, Tanya,1973-
FC3662.L66 1997 971.23'03'0222 C96-910743-9
F1076.8.L66 1997

The publisher acknowledges the support of the Canada Council and the
Cultural Services Branch of the Government of British Columbia in making
this publication possible.

Alberta boasts some of the most dramatic landscapes on earth. Nothing here was made in moderation—this is a world of towering cliffs, giant rivers, and infinite prairie. Sculpted by erosion over thousands of years, the eerie shapes of hoodoos rising over the badlands are more reminiscent of an alien planet than of North America. Likewise, the sharp and barren peaks of the Rockies' Front Ranges are like nothing else in Canada.

Since the beginning of European settlement, residents, business people, and government have combined forces to preserve the land. Alberta is home to both Canada's first national park, Banff, and the world's first international park, Waterton-Glacier International Peace Park. Each of the province's many reserves serves a special purpose: Elk Island offers refuge to threatened elk and bison; Cypress Hills encompasses a distinctive plateau in the centre of sprawling grasslands; and Dinosaur Provincial Park boasts one of the world's richest fossil beds.

In protecting the land, Alberta has also preserved a wealth of history. The heritage of Ukrainian immigrants, Mormon settlers, and First Nations is celebrated in numerous communities. At Head-Smashed-In Buffalo Jump, for instance, First Nations guides lead visitors through the ancient traditions of the bison hunt.

Although most people once lived in rural areas, the province is growing steadily more urban. Profits from oil and agriculture have spurred the growth of Calgary, transforming the city into a modern metropolis of mirrored glass and high technology. In Edmonton, growth brought the development of the West Edmonton Mall, the world's largest shopping centre and a magnet for thousands of tourists.

In *Alberta*, photographers have revealed this booming city lifestyle. They have also travelled the province's 660,000 square kilometres to capture an array of remote and spectacular sites. In these pictures, you will discover the diversity of the province, from the populous cities to the alpine meadows of the Rockies.

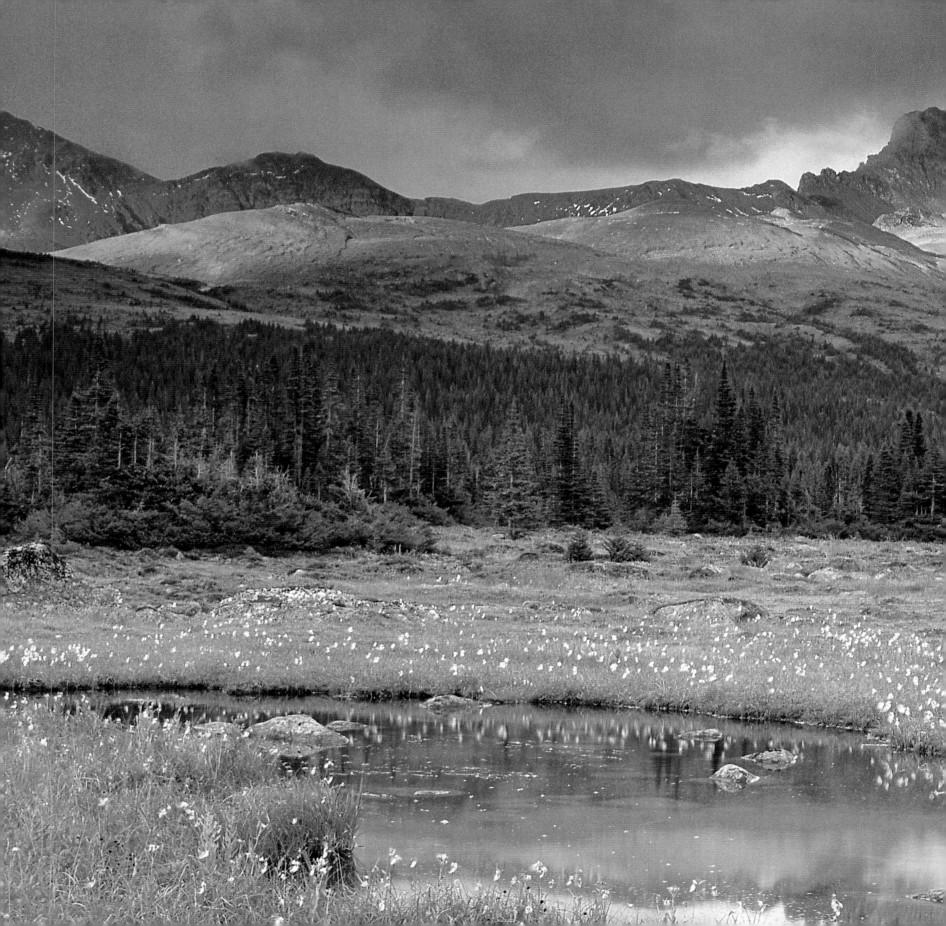

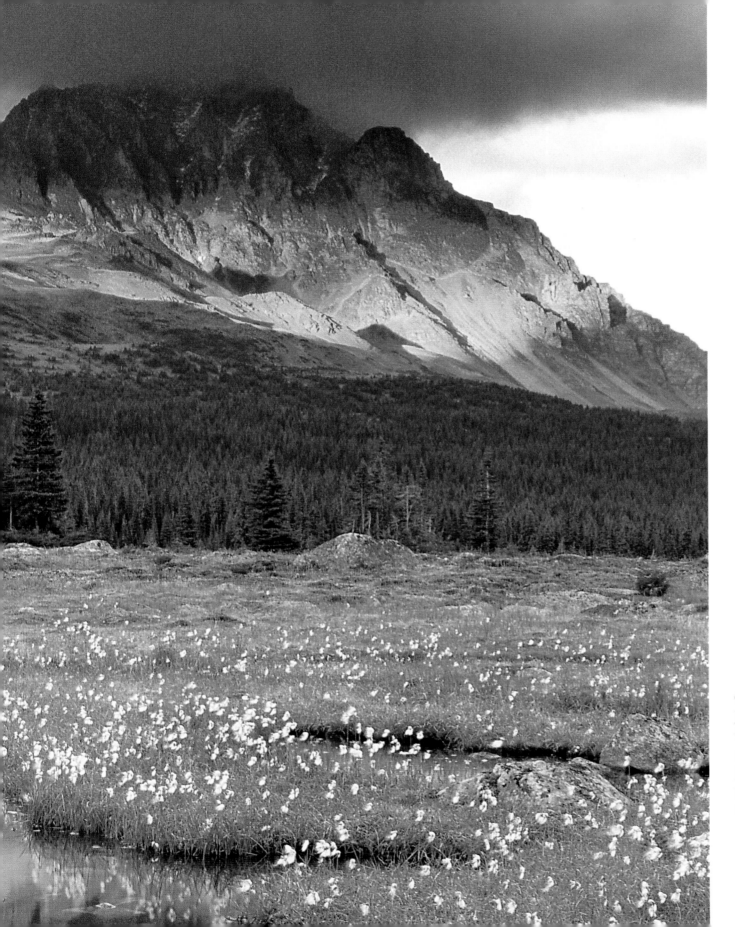

Only one-tenth of
Jasper National Park
is valley bottoms. The
rest is pure height —
jagged cliffs, glaciers,
peaks, and alpine
meadows.

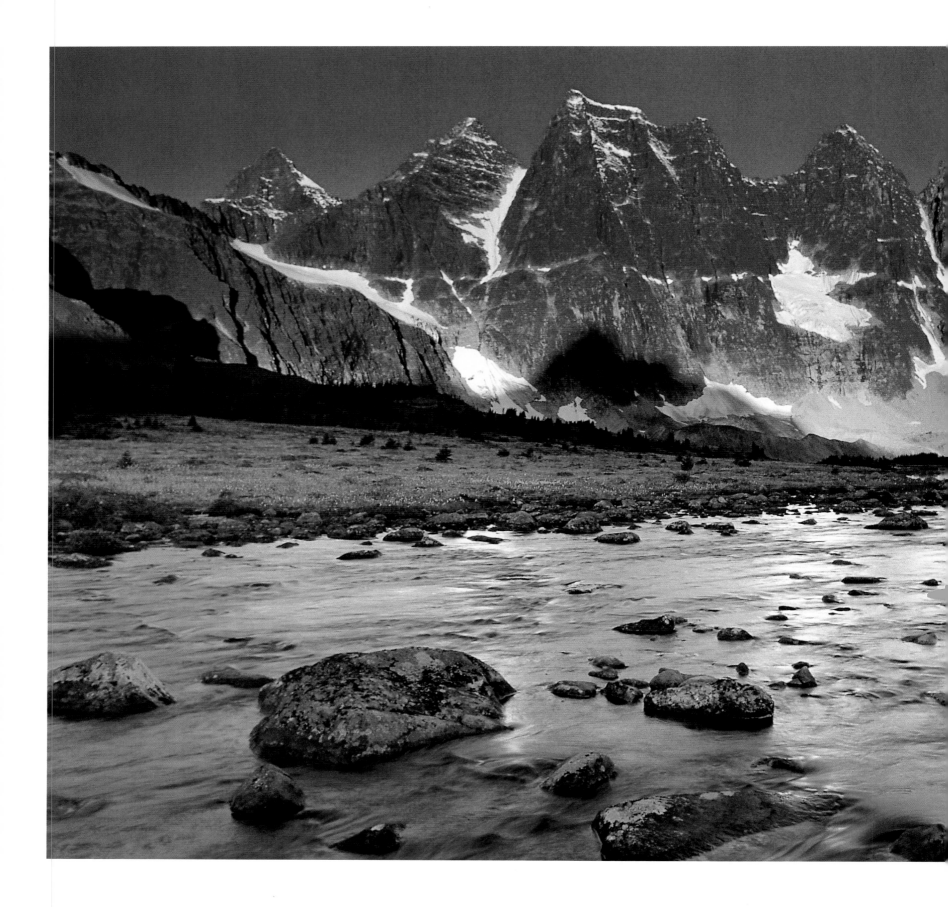

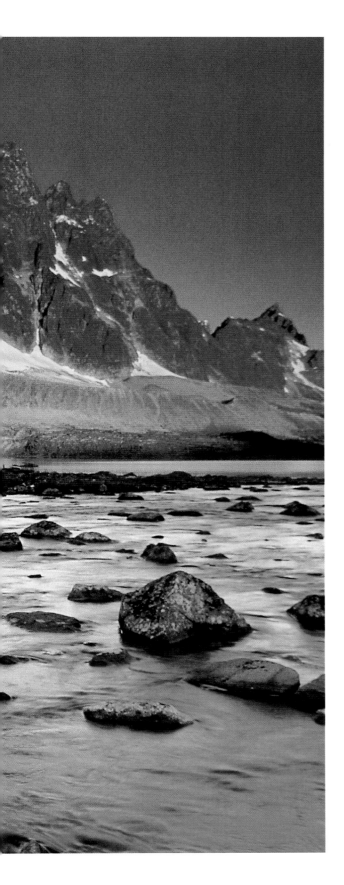

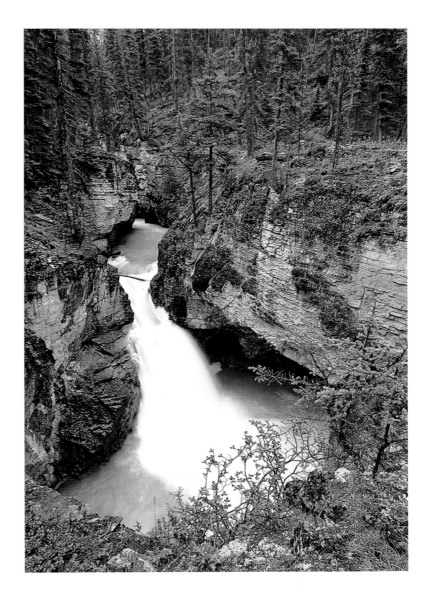

Swollen by glacial water from the Columbia Icefields, Beauty Creek tumbles over Stanley Falls.

The snowy crags of the Ramparts rise above Astoria River in Jasper National Park.

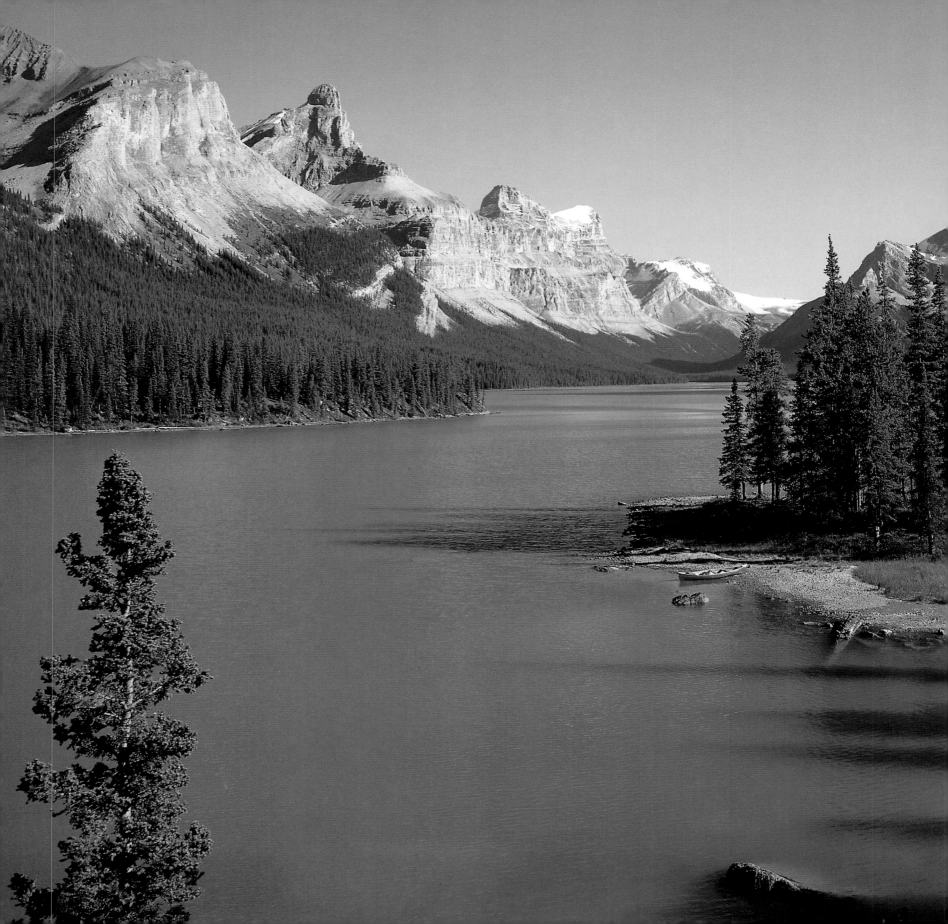

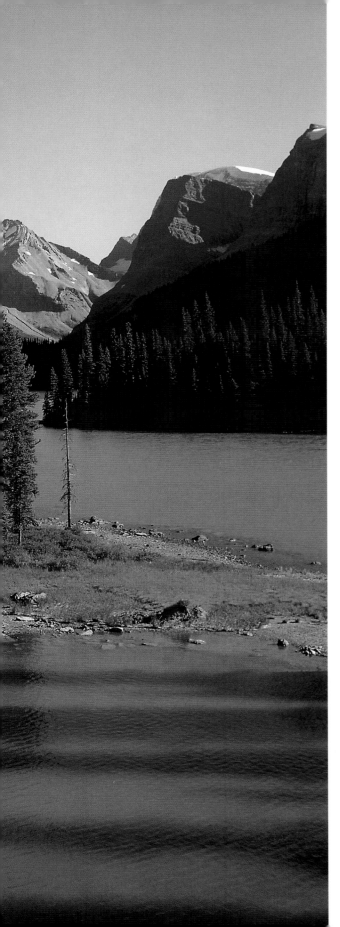

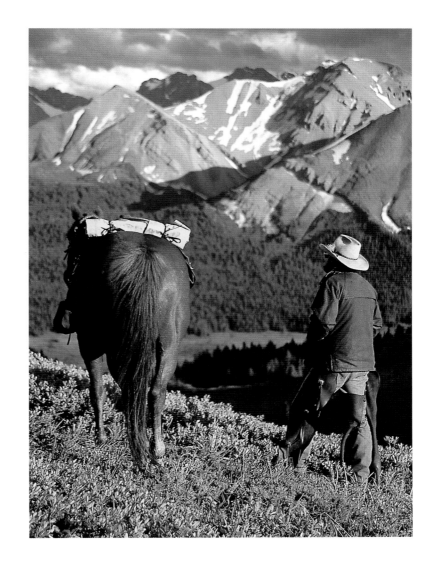

North of Jasper, Willmore Wilderness Park protects an isolated expanse of the northern Rockies. With few roads, the park is a haven for hikers, horseback riders, and wildlife.

Maligne Lake, the largest in the Canadian Rockies, stretches for 22 kilometres. Its views are enjoyed by day hikers and canoeists.

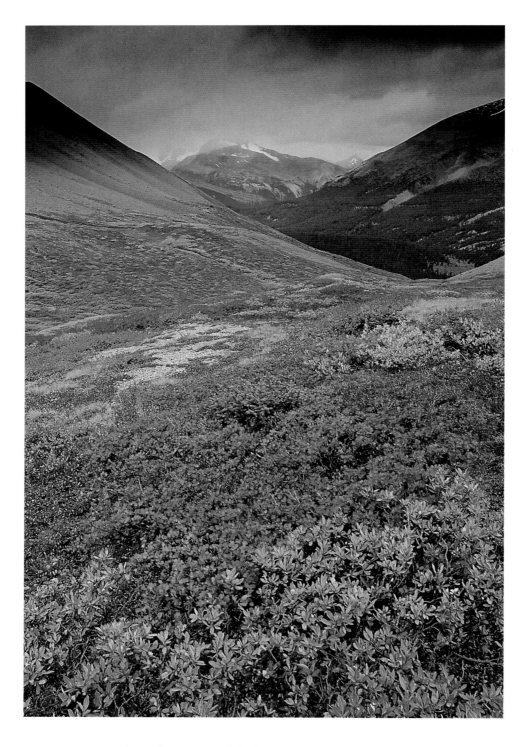

Jasper National Park was established to attract railway
passengers in the early 1900s. It was named after
Jasper Hawes, the manager of a nearby fur-trading post.

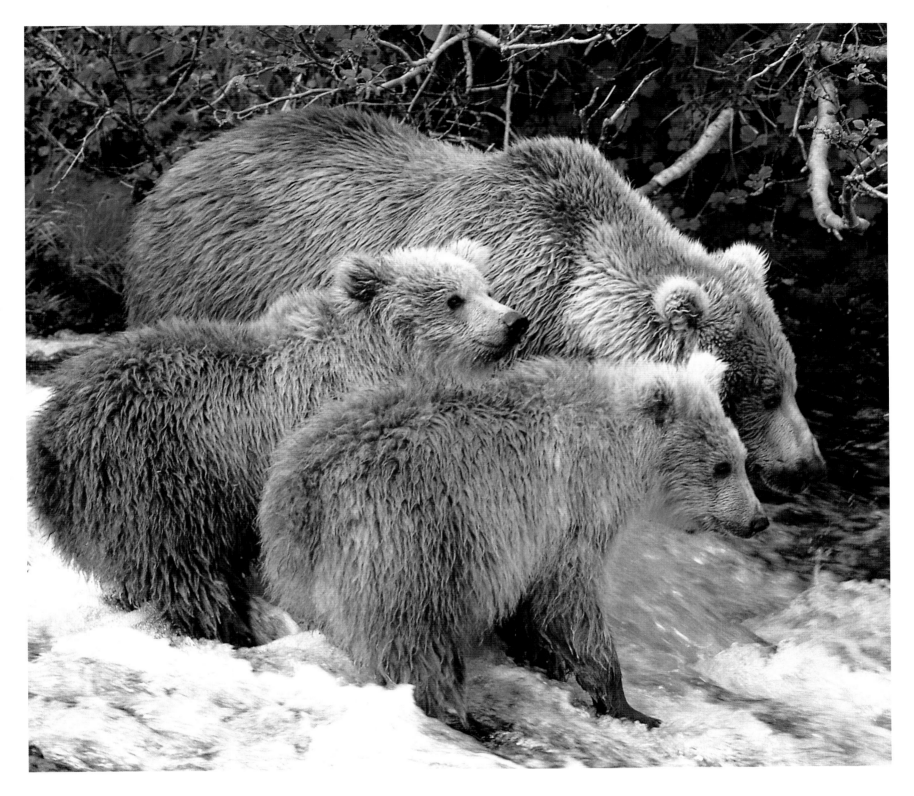

Threatened across North America by encroaching human settlement, the grizzly bear finds a necessary sanctuary in the connecting wilderness parks of the Rockies.

One of Banff National Park's most popular attractions is Lake Louise, a stunning 2.4-kilometre-long lake fed by Victoria Glacier, visible in the distance.

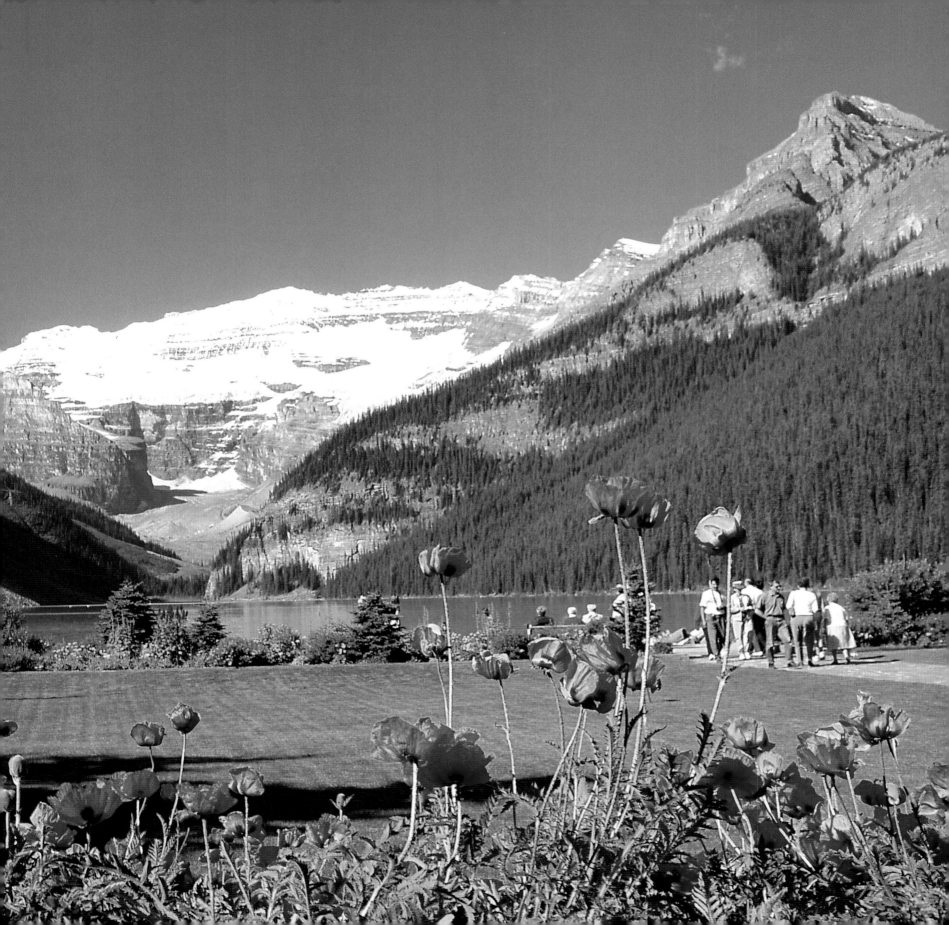

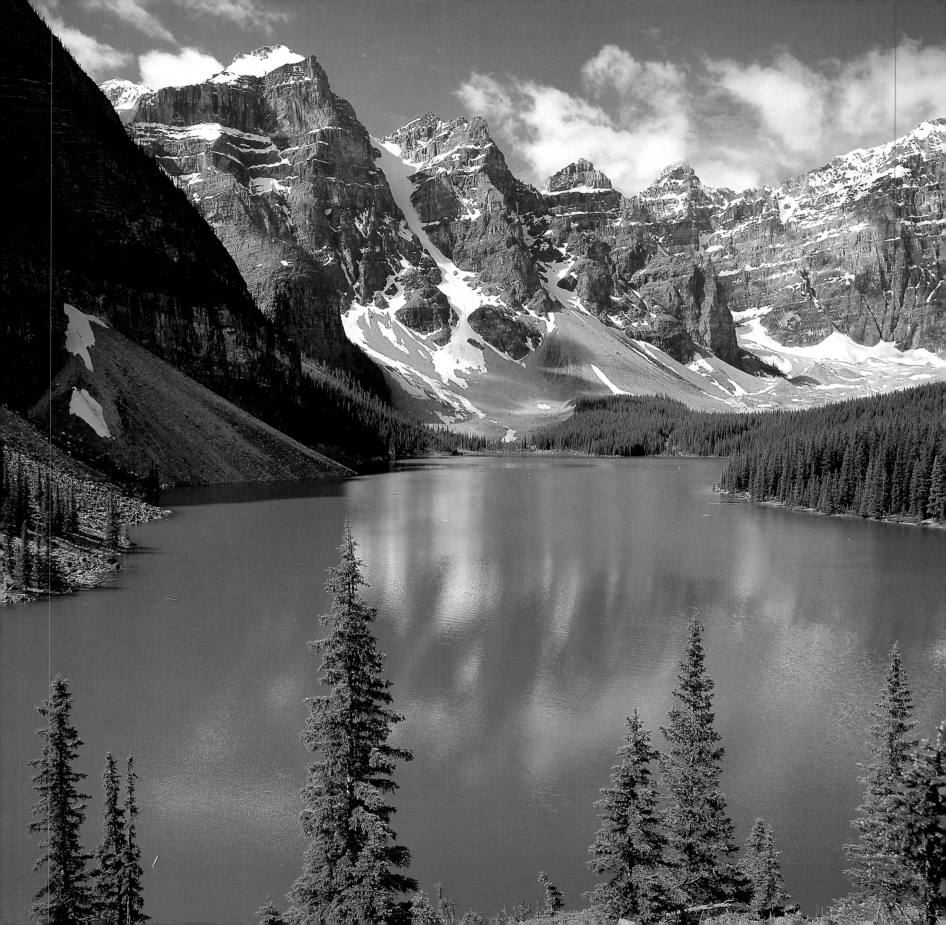

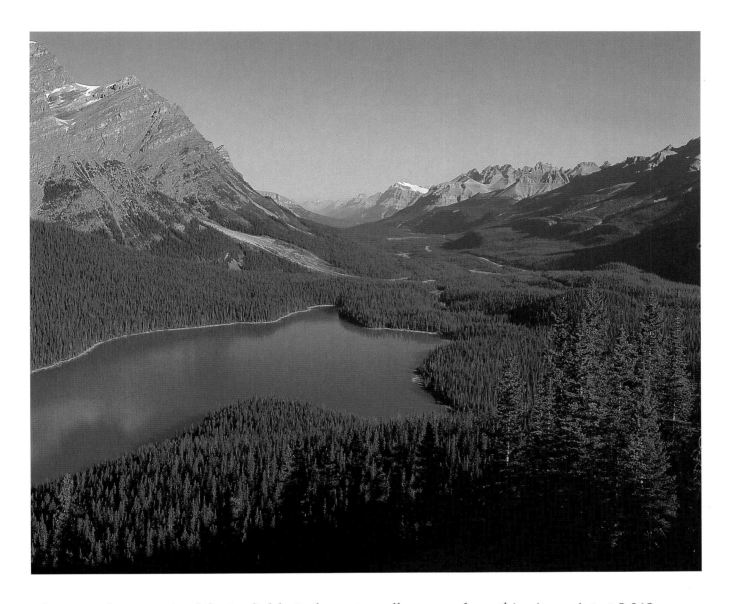

Almost at the summit of the Icefields Parkway, travellers gaze from this viewpoint at 2,069 metres down on the deep blue expanse of Peyto Lake. The lake is named after Bill Peyto, a British outfitter whose knowledge of the Rockies made him one of the area's most respected guides.

Canadians may recognize this view—Moraine Lake was on the back of the old $20 bill. The lake is surrounded by the Valley of the Ten Peaks, named by climber Samuel Allen.

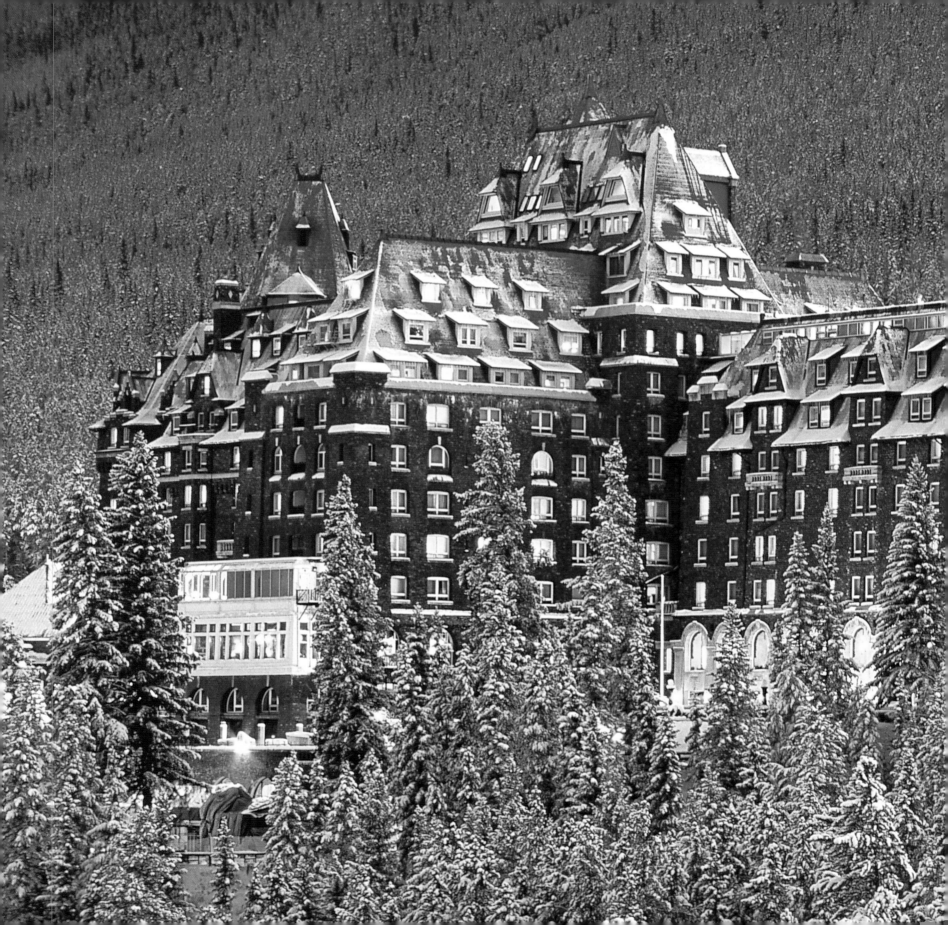

When it opened in 1888, the 250-room Banff Springs Hotel was the largest hotel in the world and rooms were $3.50 a night. Prices have gone up, but the hotel still draws visitors from around the world.

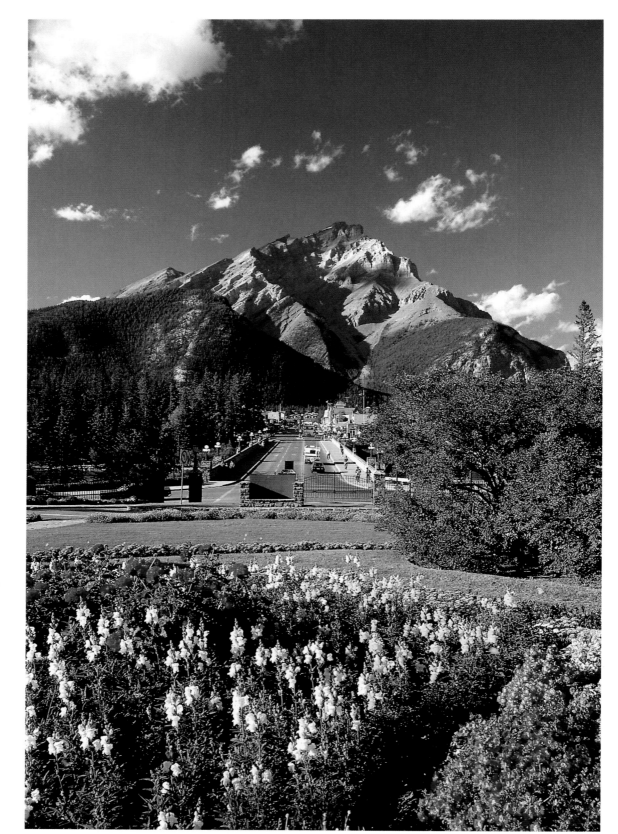

Only 7,000 people live in Banff, but in summer 50,000 tourists a day swarm through the restaurants and gift shops. Banff also hosts a series of nationally respected artists' workshops on topics ranging from painting to filmmaking.

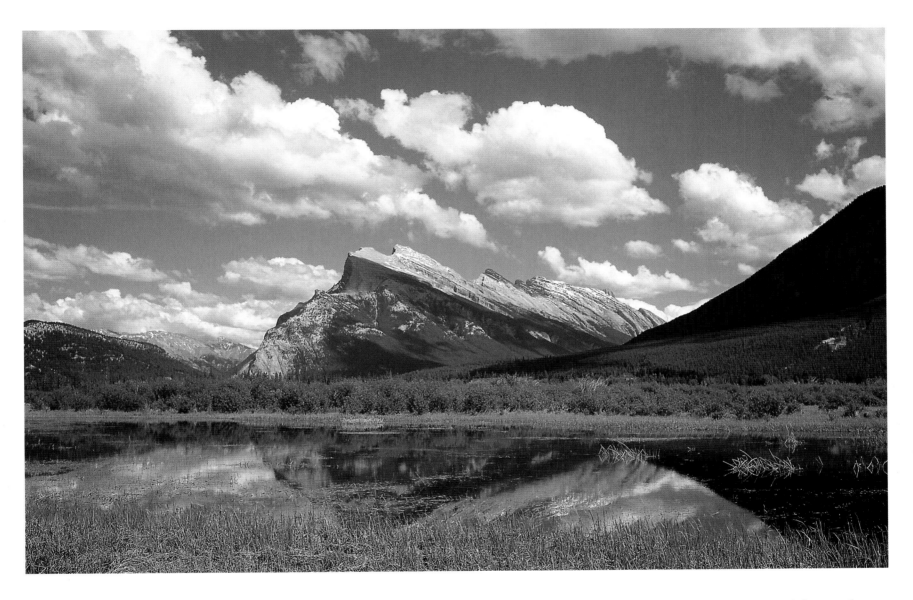

Banff National Park highlights the diverse geography of the Rockies. West of the townsite, the marshy shore of Vermilion Lake contrasts sharply with the 2,949-metre heights of Mount Rundle.

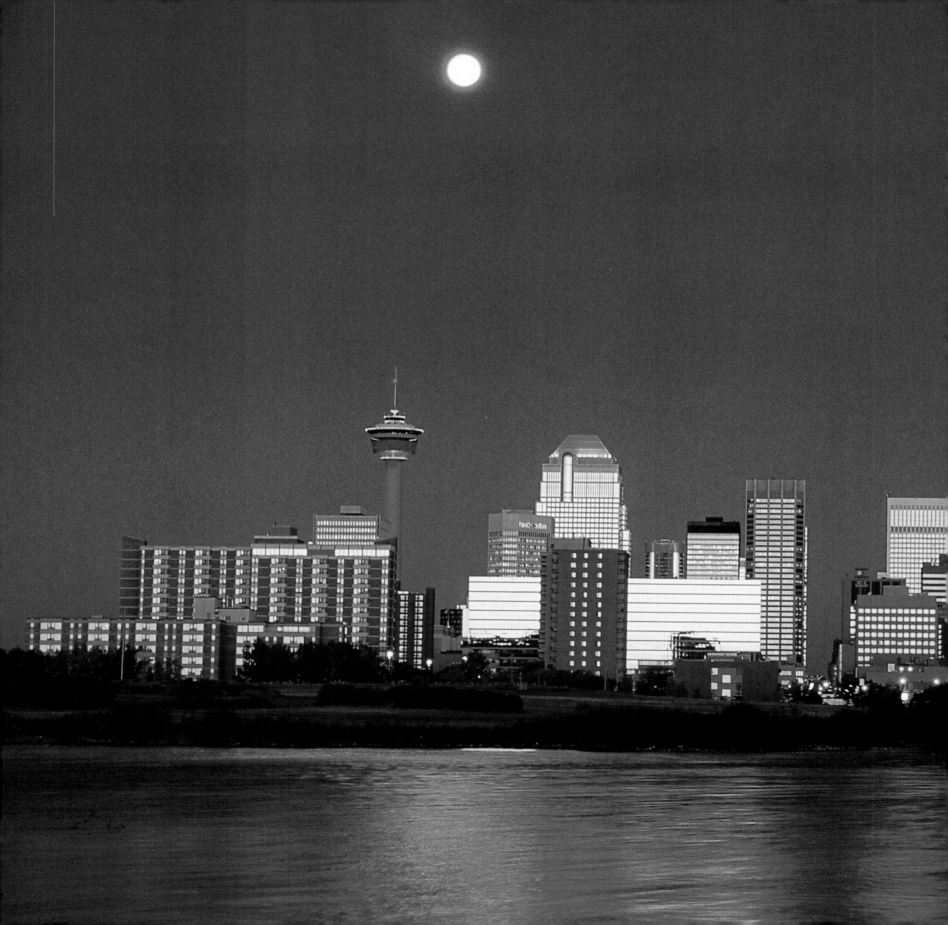

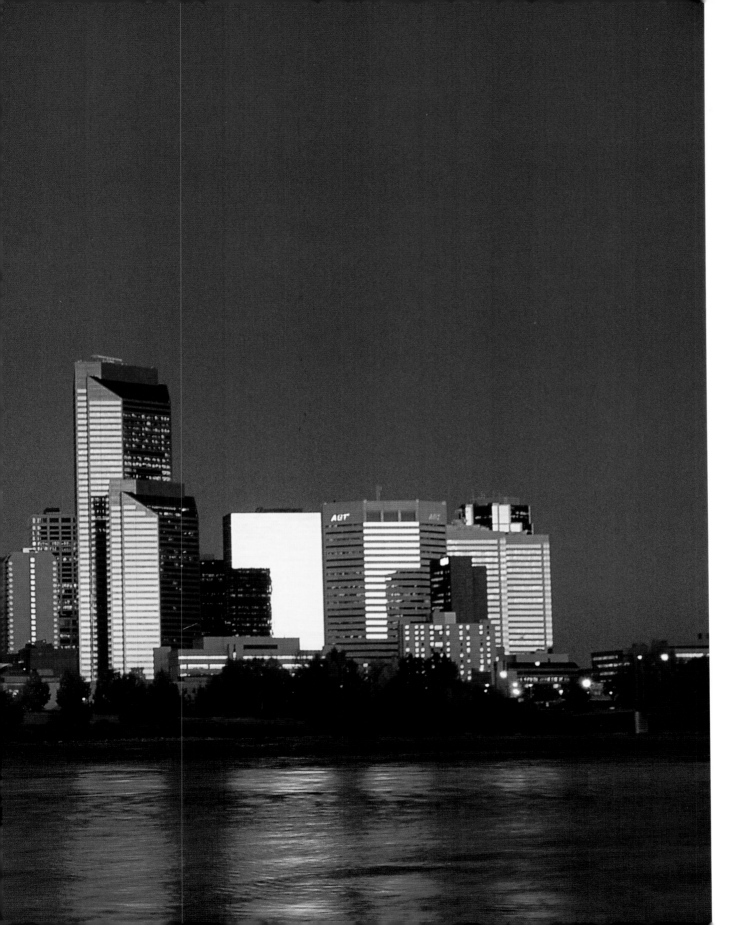

In 1875, the North-West Mounted Police founded a post named Fort Calgary along the Bow River. Oil, agriculture, and tourism events like the Calgary Stampede helped the city grow into a major financial centre.

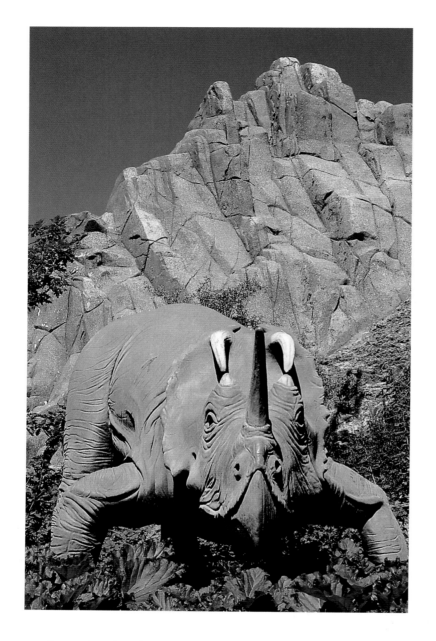

It almost looks alive. This centrosaurus is one of 27 life-sized dinosaur replicas that co-exist with more than 1,000 live animals at the Calgary Zoo.

When the Calgary Flames are in town, spectators pack the Olympic Saddledome. Built for the 1988 Winter Olympics, the distinctive Saddledome seats 20,000.

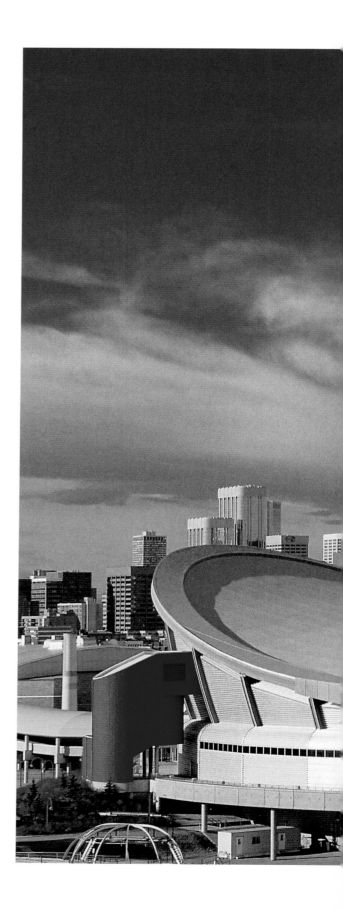

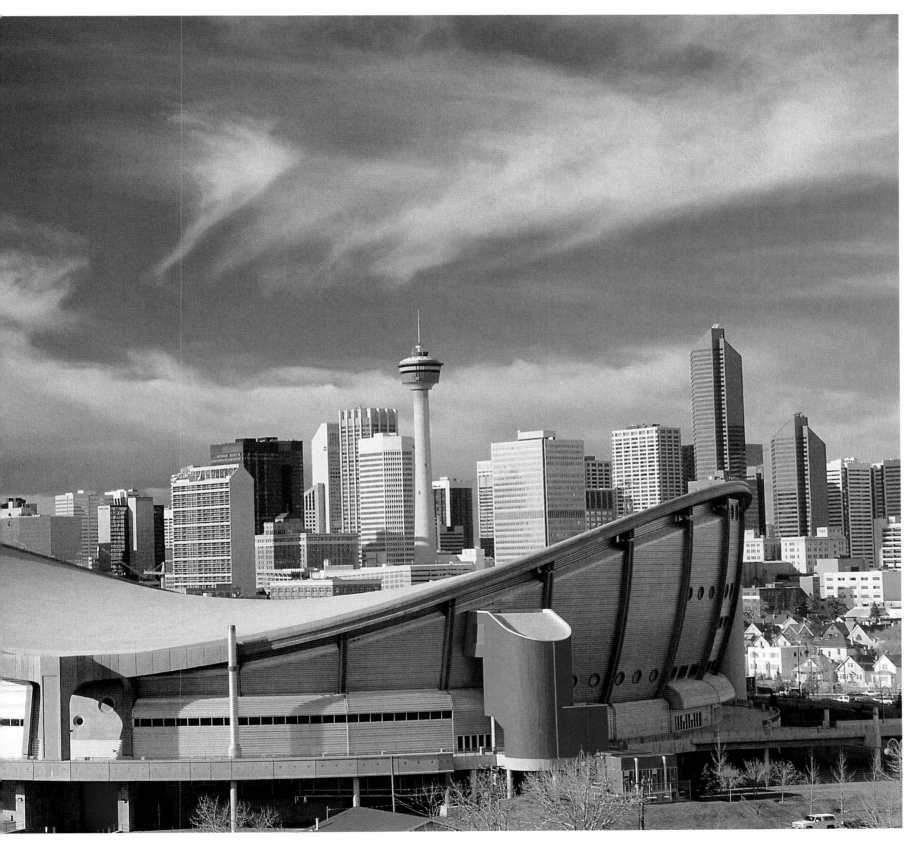

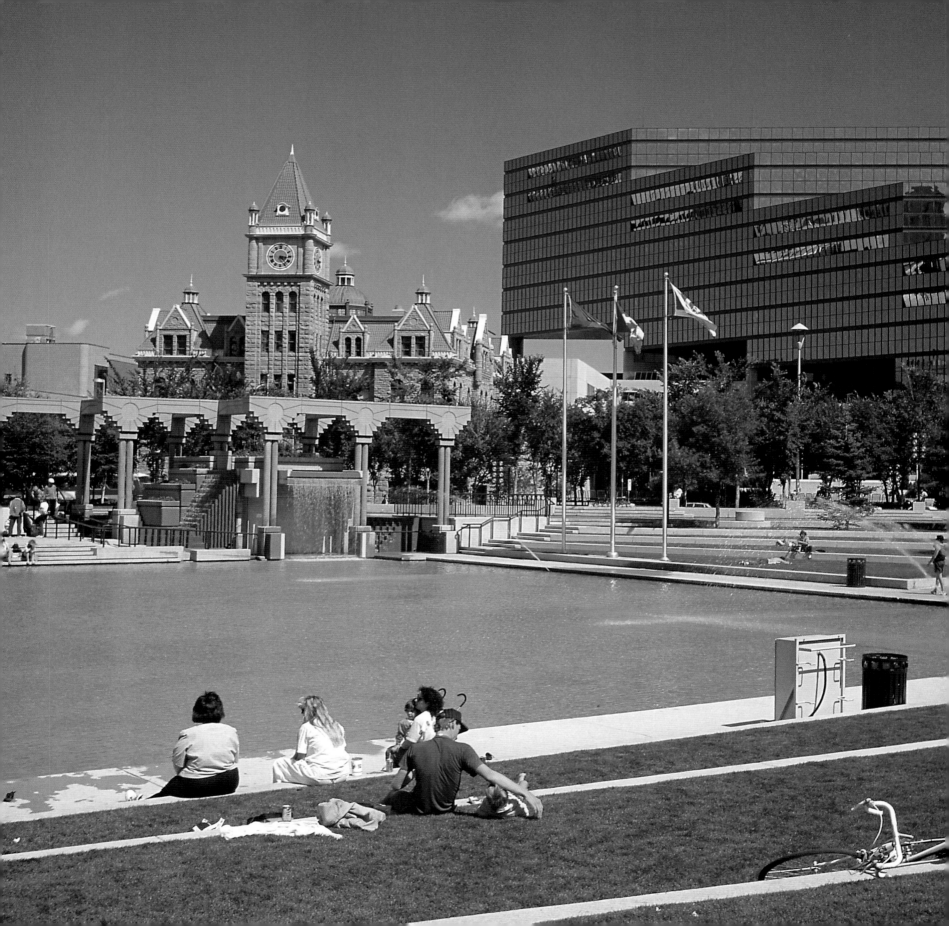

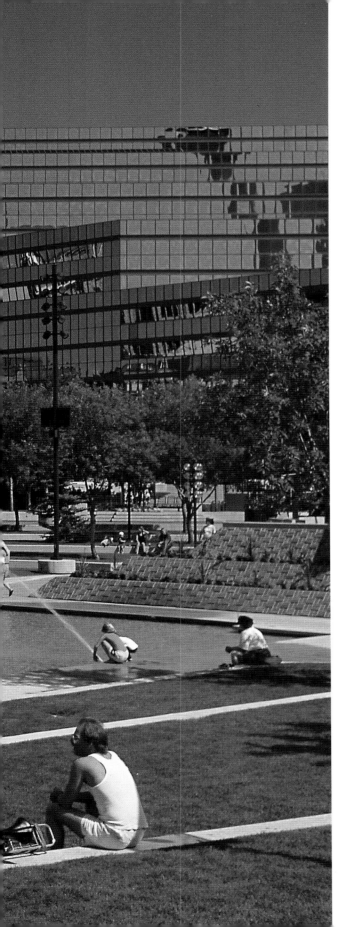

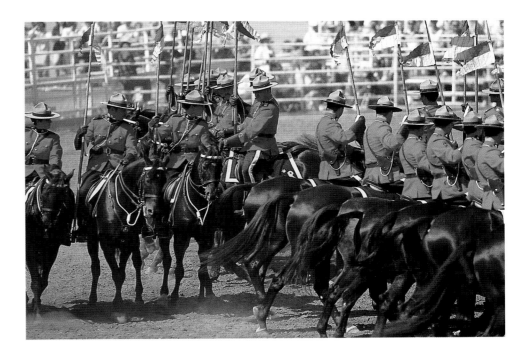

In a city founded by the mounted police, it seems appropriate that the RCMP Musical Ride entertains visitors to the annual Calgary Exhibition and Stampede.

Calgary's Olympic Plaza is a relaxing oasis in summer and a skating rink in winter. The old and new city halls rise in the background.

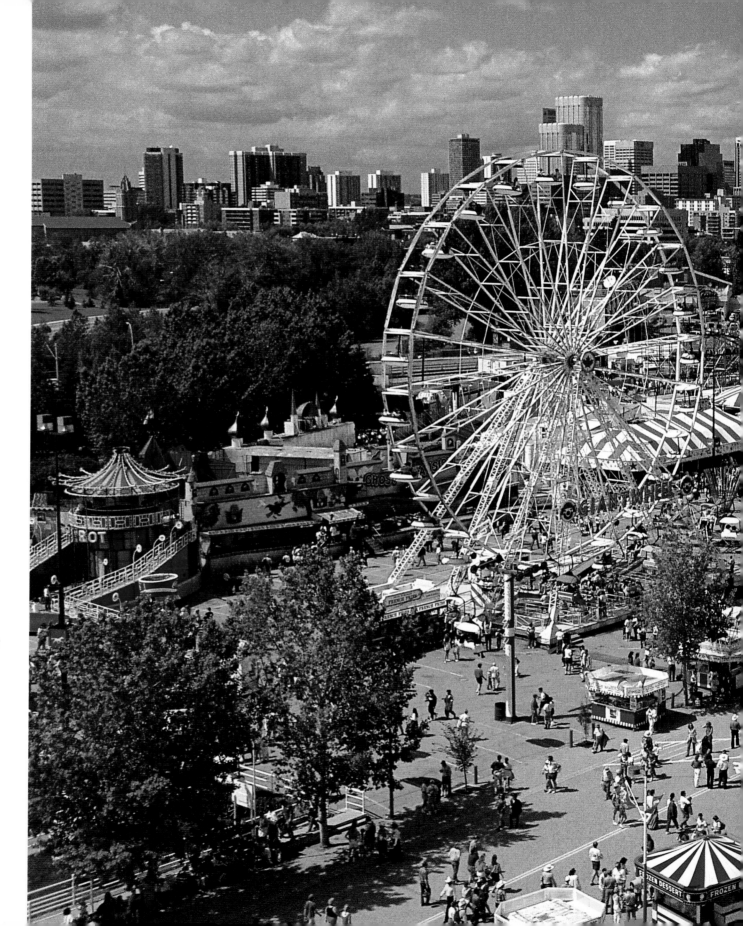

The Stampede attracts more than one million visitors each July to the 38-hectare Stampede Park. Some 1,700 volunteers and 1,500 employees look after the crowds and keep events on schedule.

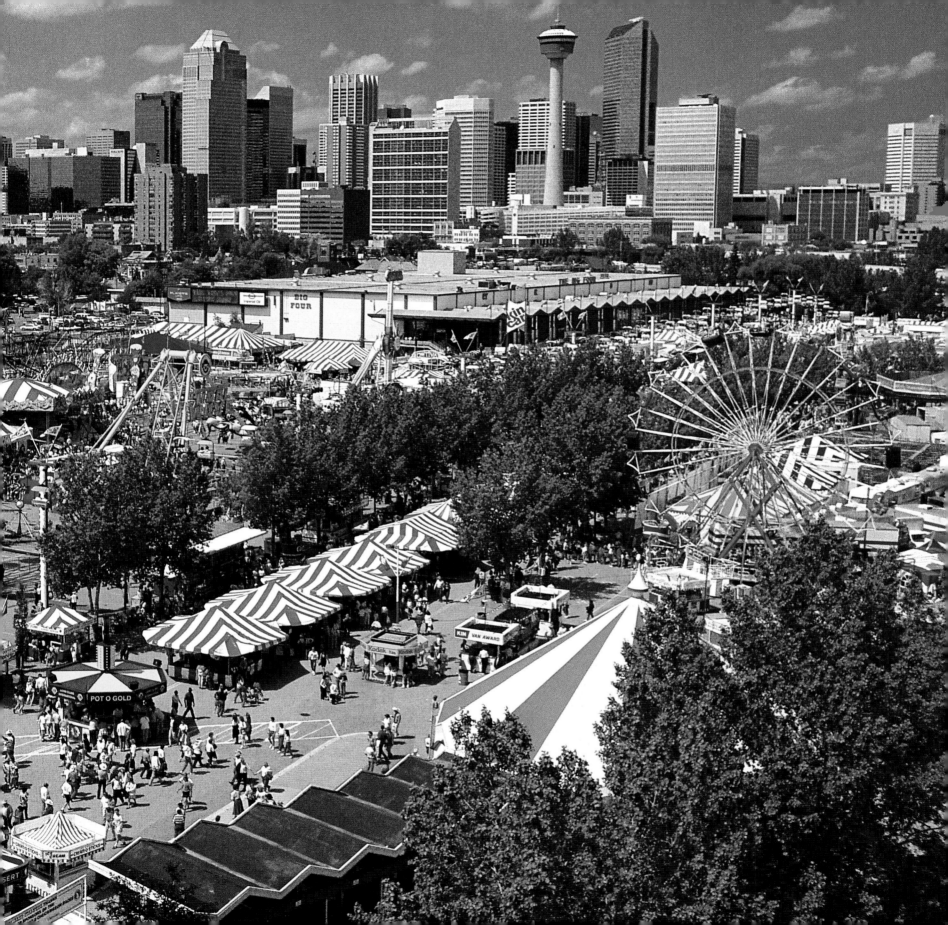

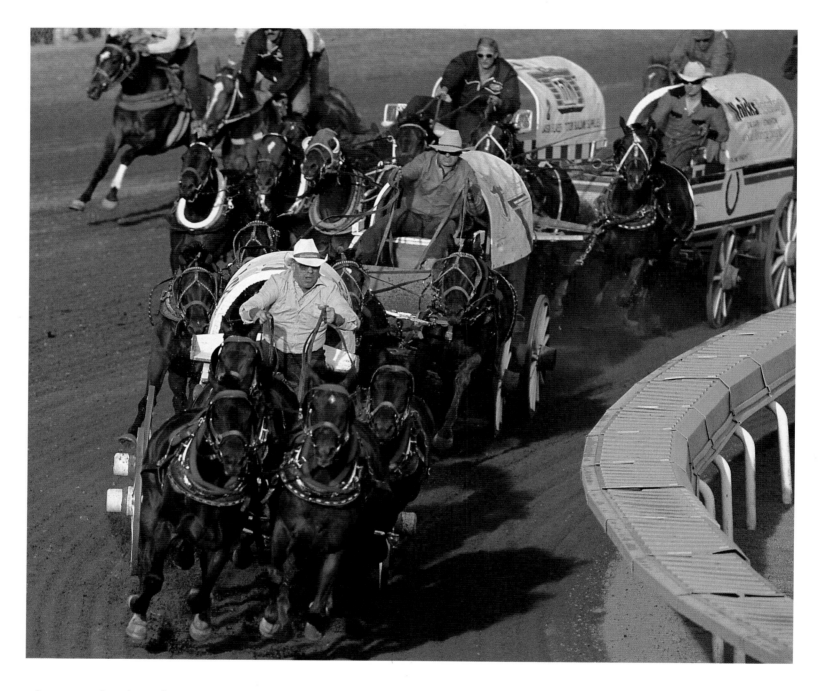

The Rangeland Derby was first held in 1923—
history's earliest formal chuckwagon race.

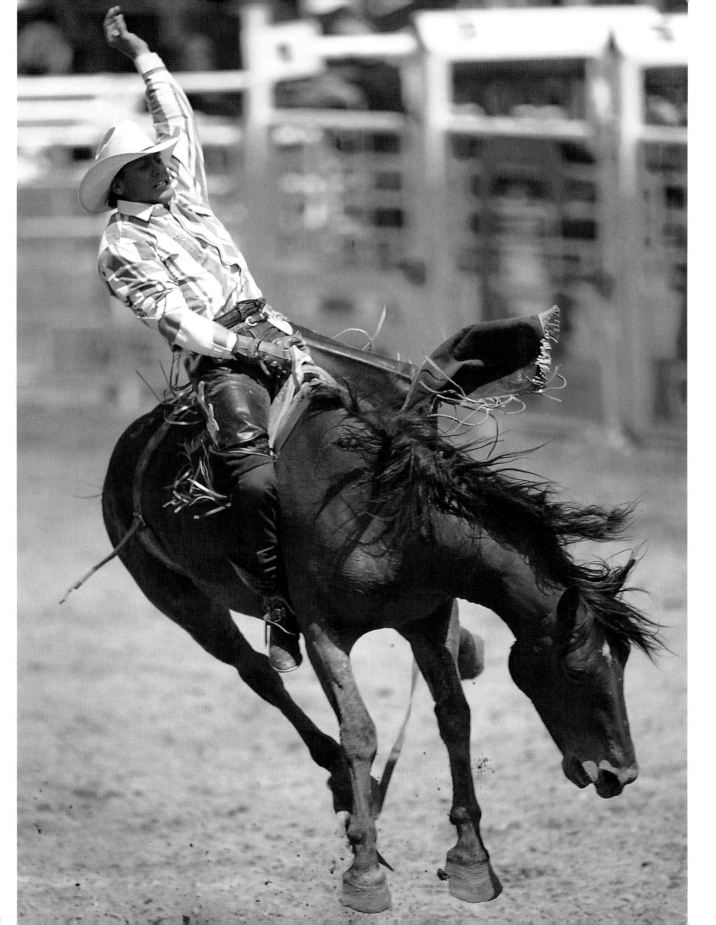

Professional cowboys strut their stuff at the Calgary Stampede, the largest rodeo on earth. Bronc riding is one of the world's roughest events and there is tough competition for the $50,000 first prize.

Kananaskis Country encompasses Peter Lougheed, Bow Valley, and Bragg Creek provincial parks in a sprawling, 4,250-square-kilometre, multi-use preserve. The area offers everything from secluded campsites to Olympic-level downhill skiing.

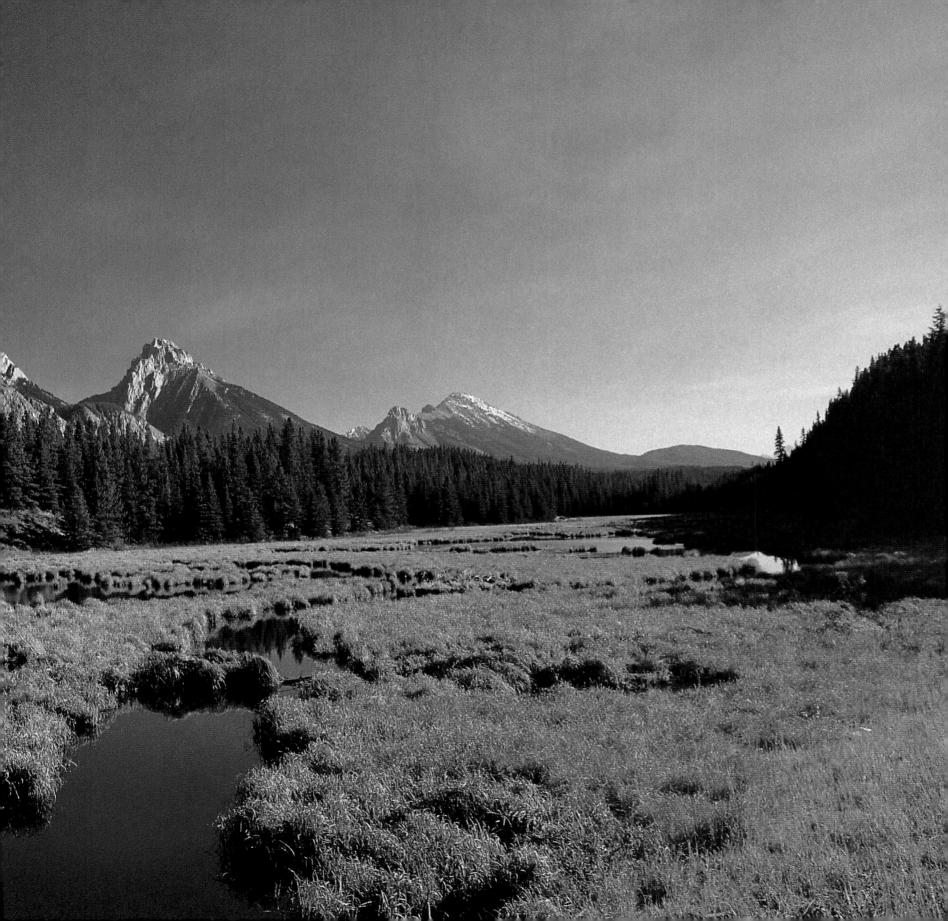

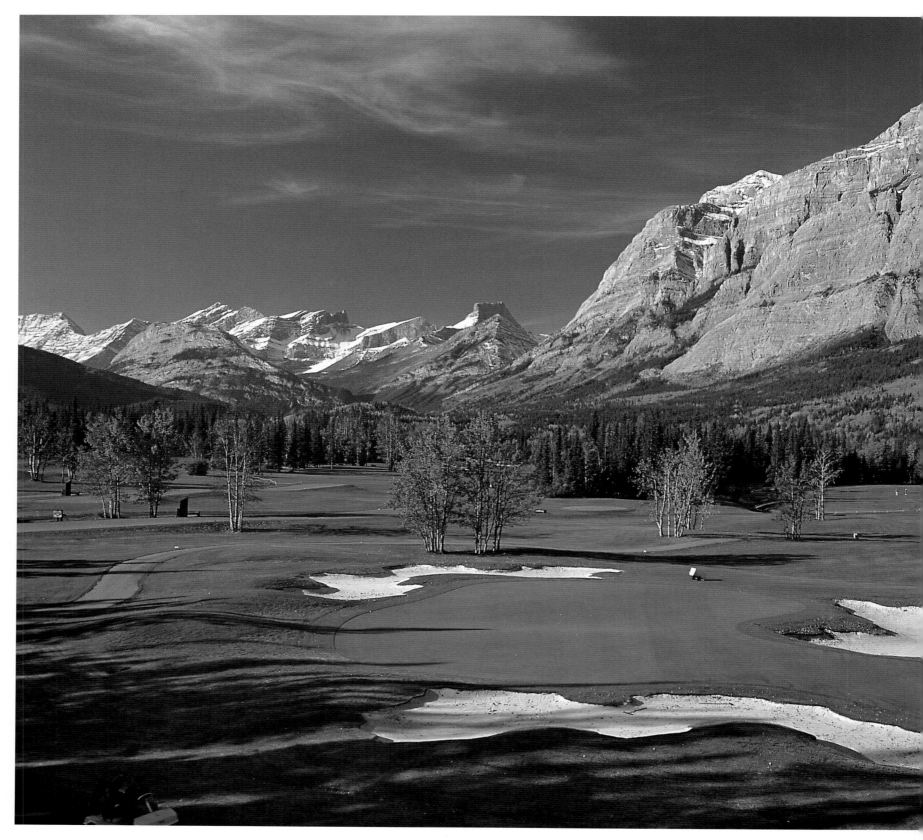

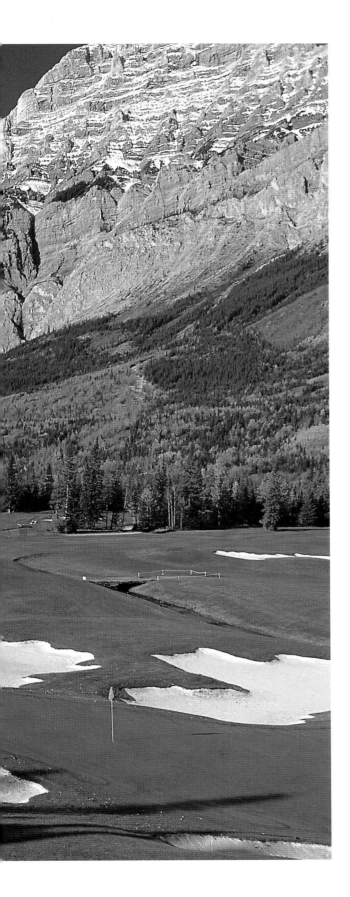

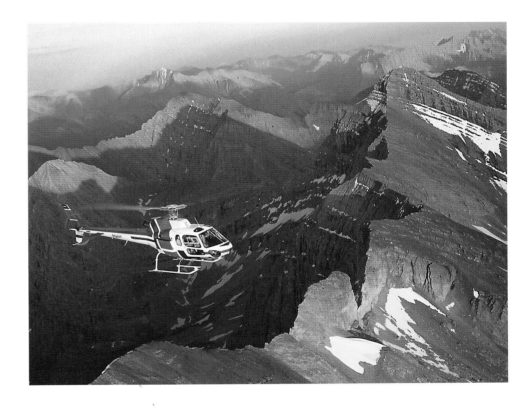

A helicopter hovers over the Front Ranges of the Rockies as a photographer captures a magnificent view of the sawtooth peaks.

Golfers book tee times months in advance to play a round at the sweeping 36-hole Kananaskis Golf Course.

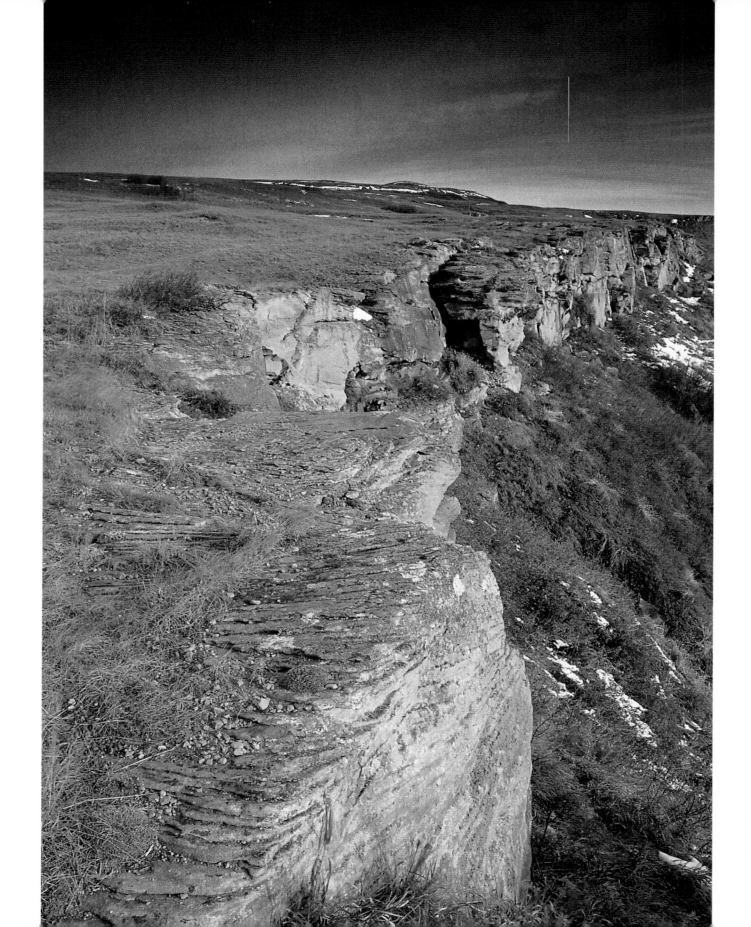

Before the arrival of Europeans and firearms, native hunters drove herds of bison over cliffs such as the one at Head-Smashed-In Buffalo Jump. Scientists estimate that hunters began using this jump 5,700 years ago; the bones at the base are piled 10 metres deep.

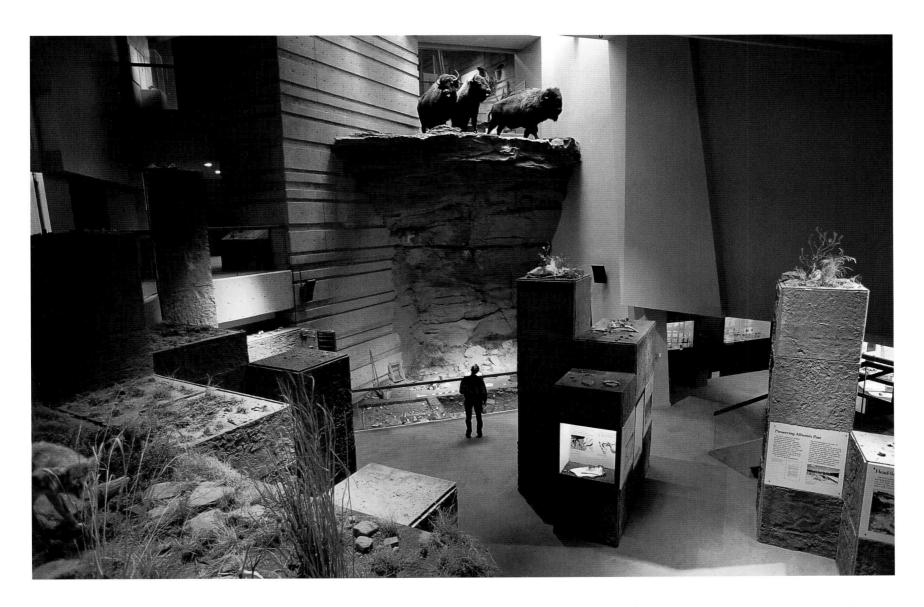

The interpretive centre at Head-Smashed-In Buffalo Jump is built into the hillside itself. First Nations staff are on hand to guide visitors through the hunt and the area's history.

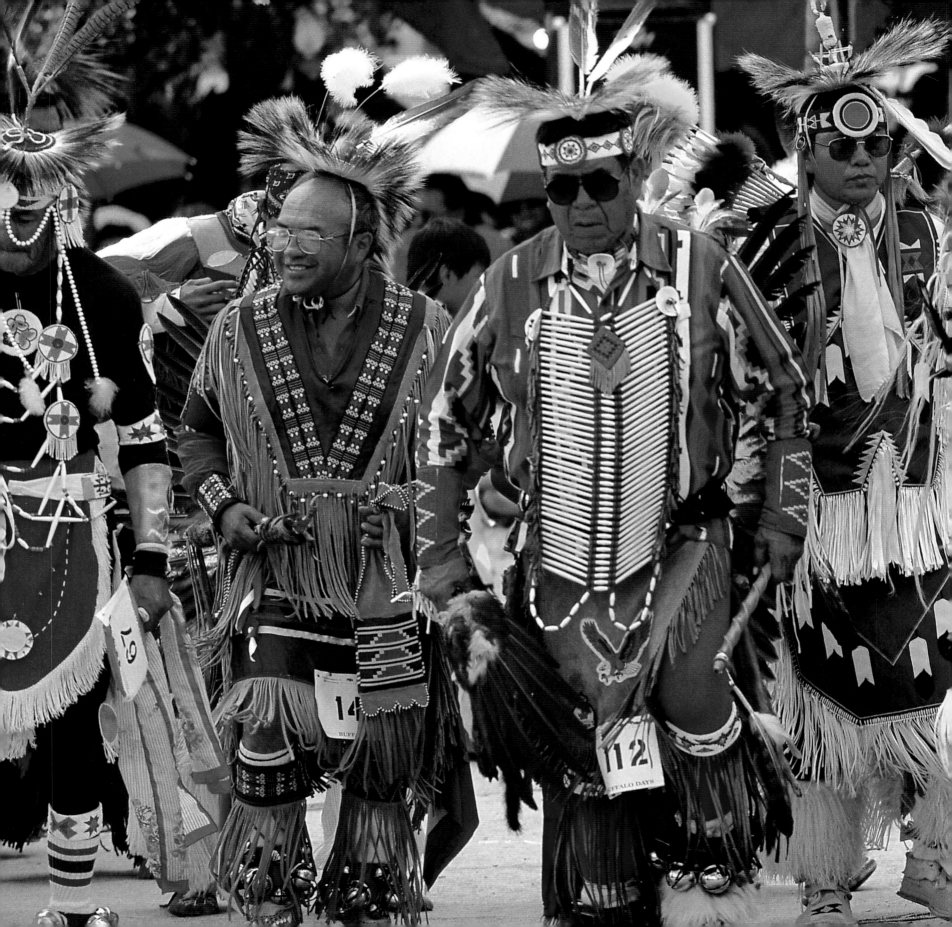

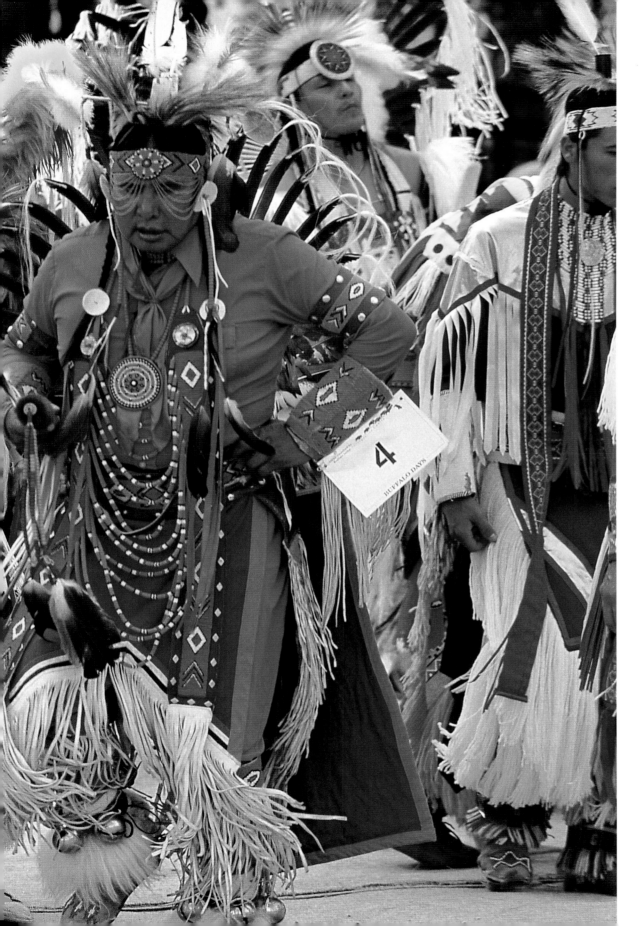

Elaborate costumes, dance competitions, and traditional songs are integral parts of the powwow held at Head-Smashed-In Buffalo Jump each July.

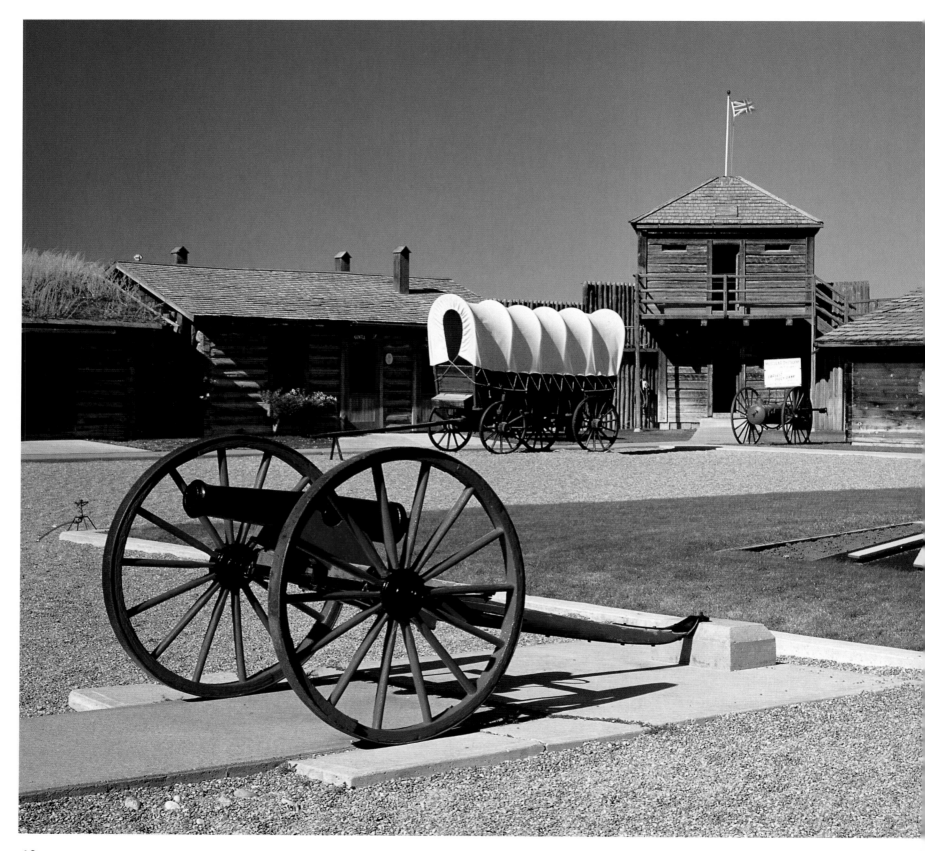

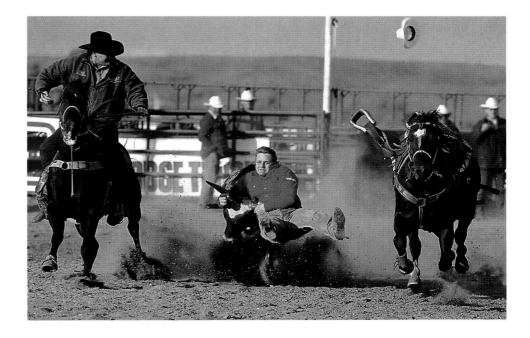

At the heart of one of Alberta's prime ranching areas, Pincher Creek has a long tradition of cowboys, cattle driving, and steer wrestling.

The Fort Macleod Museum re-creates the 1870s, when the fort, the first police post in western Canada, was built by the North West Mounted Police.

OVERLEAF –
The Prince of Wales Hotel in Waterton Lakes National Park was built by the Great Northern Railroad, an American company with a chain of resorts on the other side of the border. The luxurious hotel continues to serve both Canadian and American visitors.

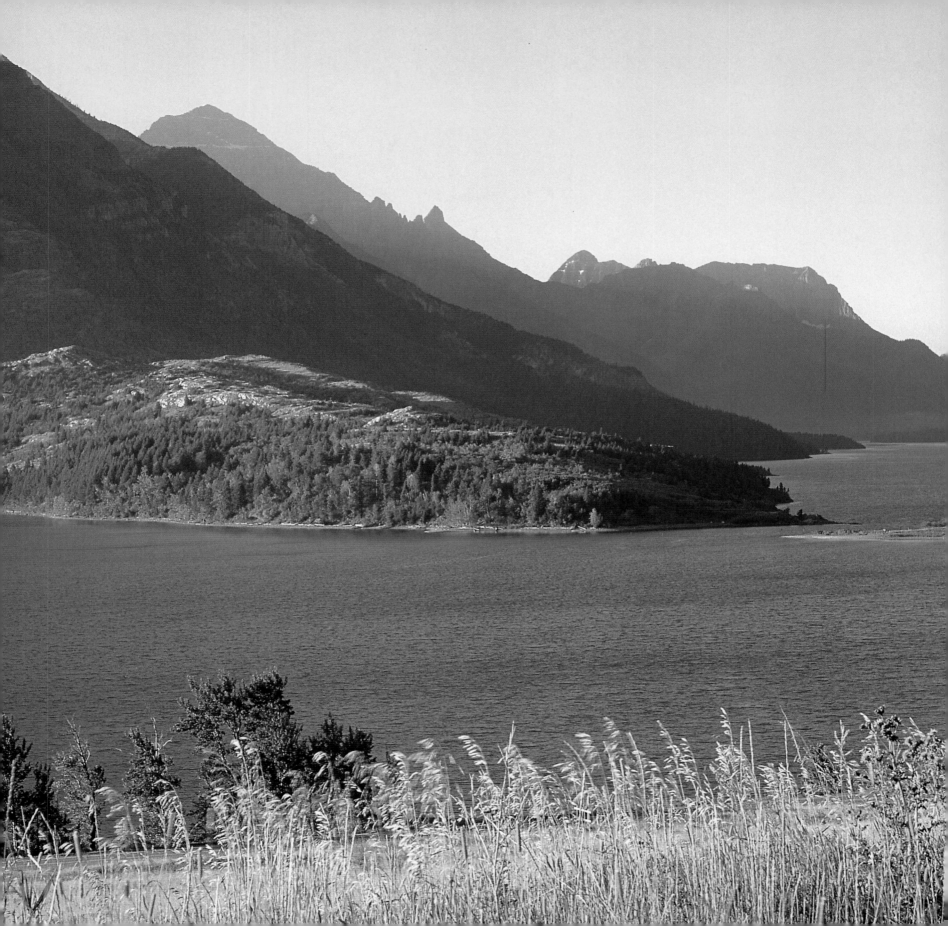

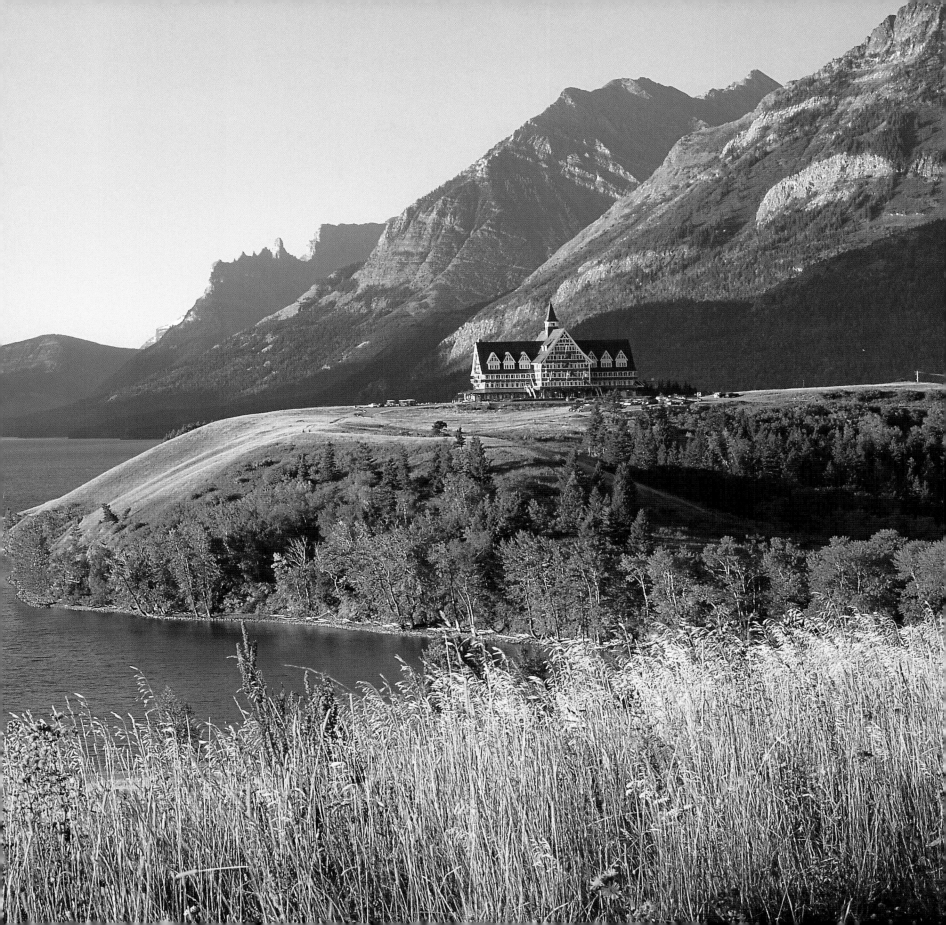

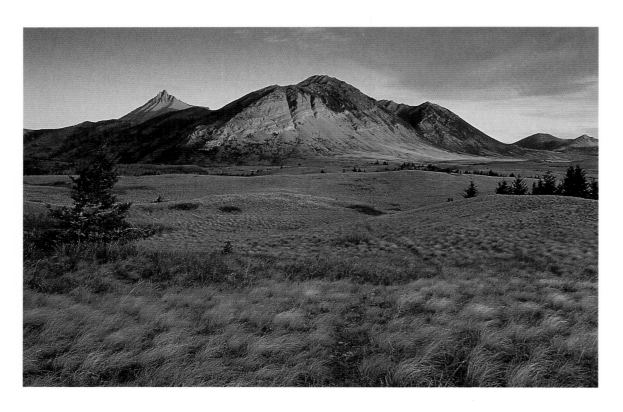

Mountains rise abruptly from the prairie at Waterton Lakes National Park. At the United States border, the park joins Glacier National Park to form Waterton-Glacier International Peace Park, the world's first co-operatively managed international preserve. Hikers follow trails across the border and back without customs formalities.

The high content of oxidized iron in the rocks along Red Rock Canyon causes the unique colour. This and other unusual rock formations throughout Waterton Lakes National Park were caused by a shift in the earth's crust millions of years ago.

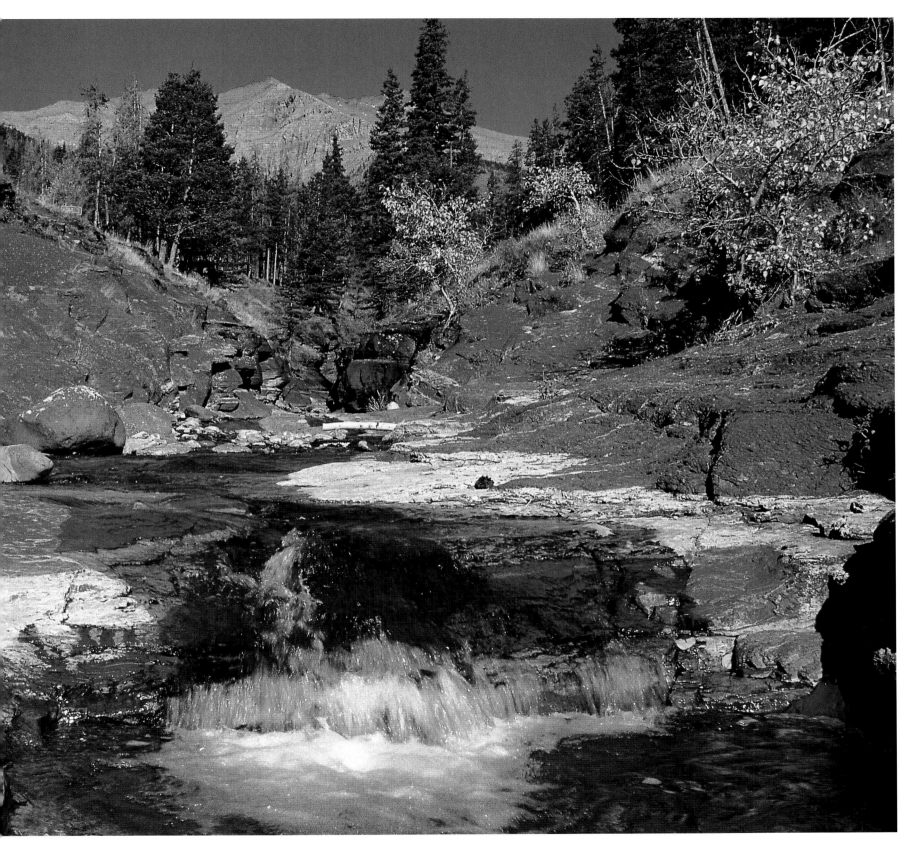

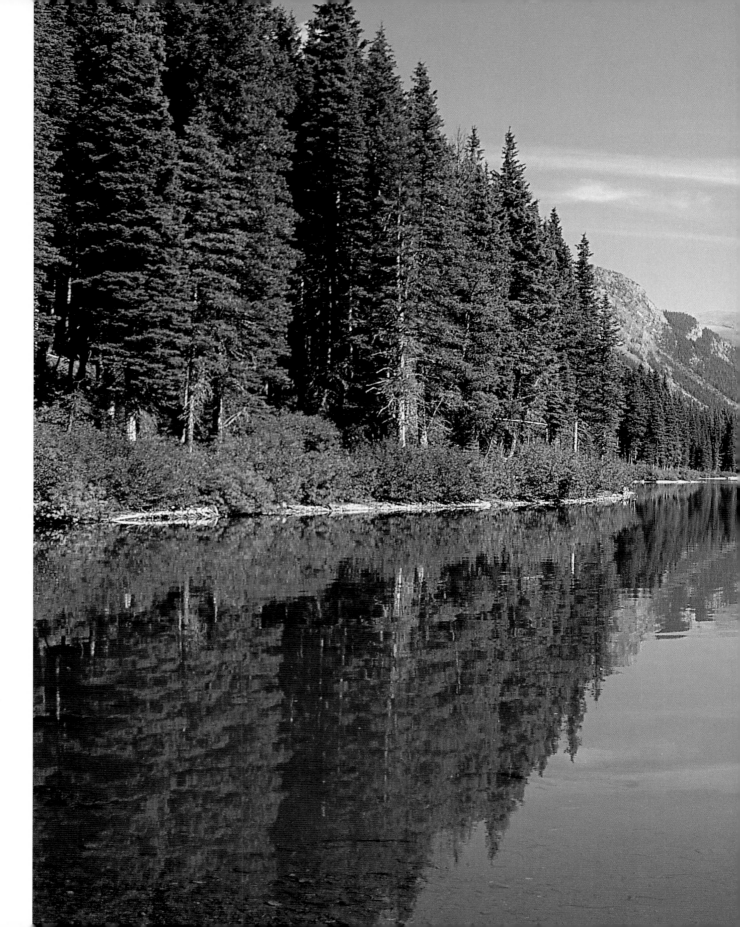

Canoeists on Cameron Lake are likely to see deer, bighorn sheep, and even grizzlies on the surrounding slopes.

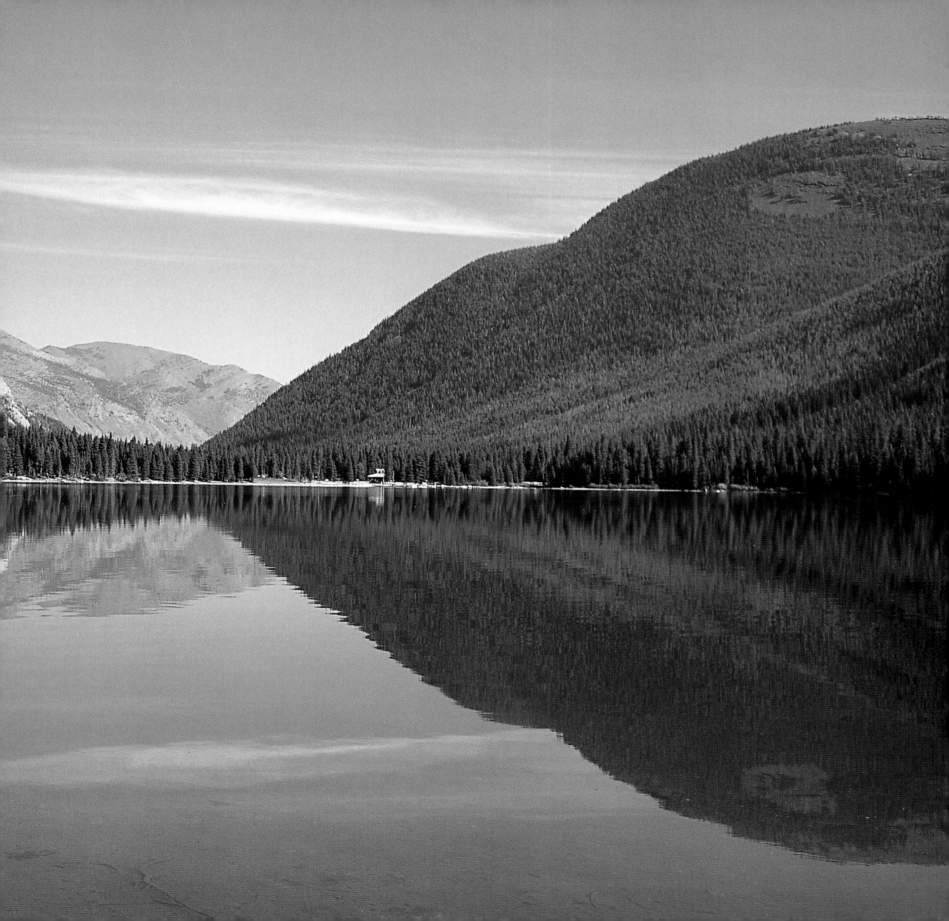

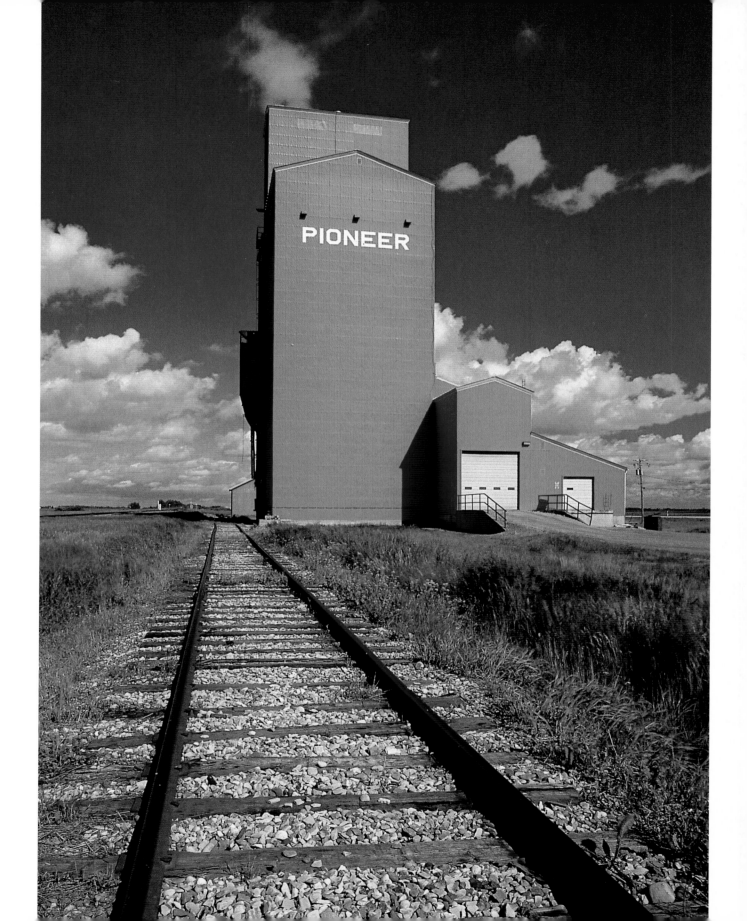

The rail lines that first brought settlers to Alberta are still a vital part of the province. Canadian National in the north and Canadian Pacific in the south connect the vast agricultural lands to their urban markets.

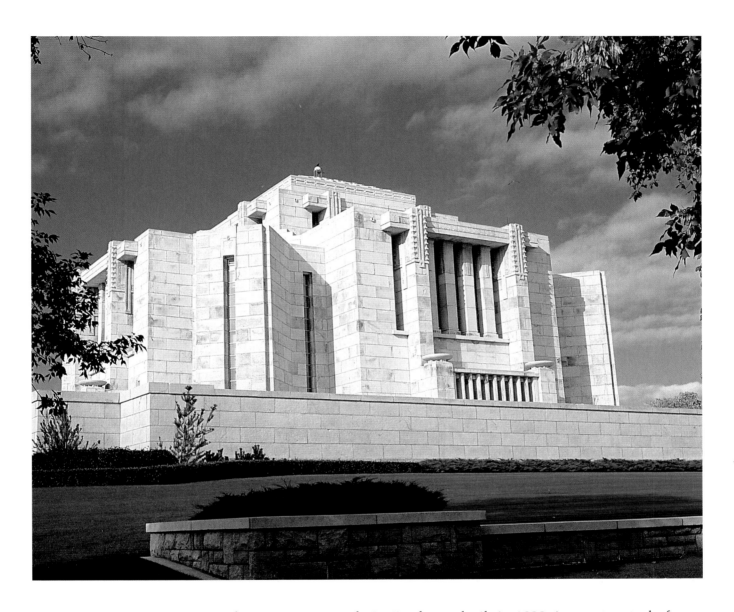

The Mormon temple in Cardston, built in 1923, is constructed of granite blocks and elaborately furnished with woodwork and murals. It has been recognized as a national monument and recently underwent major restoration.

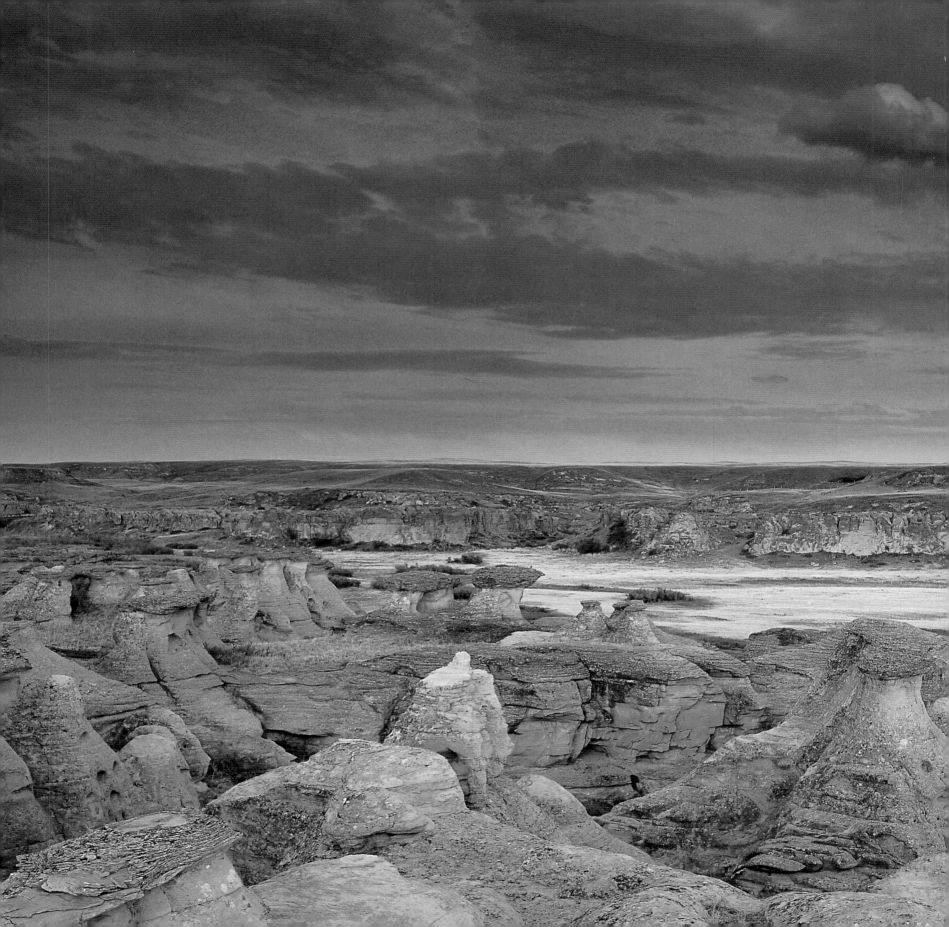

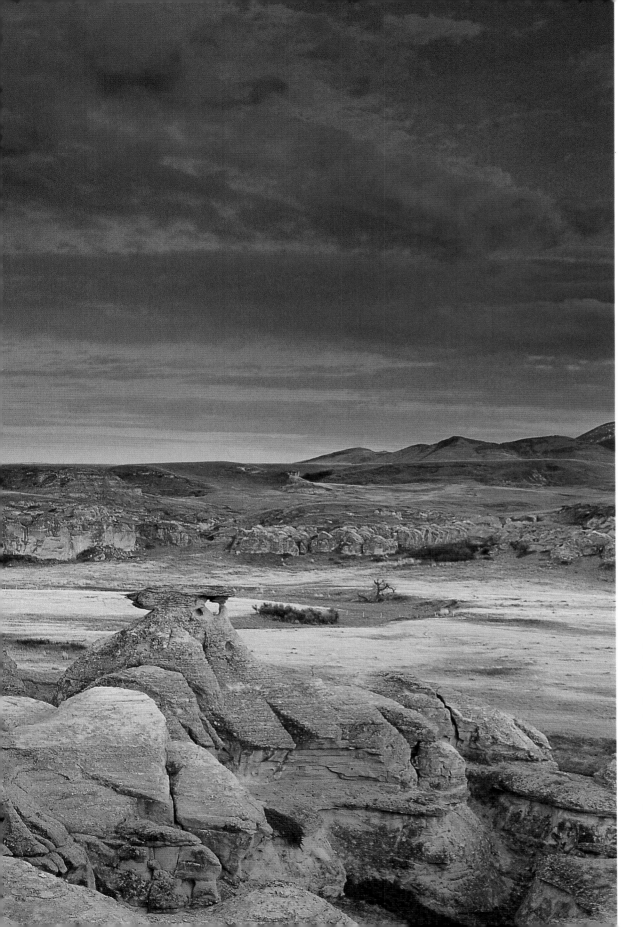

The hoodoos at Writing-on-Stone Provincial Park were formed by erosion. A hard cap tops each hoodoo, protecting it from the wind and rain that abraded the surrounding stone. Eventually, the caps are also worn away and the hoodoos diminish in size.

OVERLEAF –
Wheat is Alberta's primary crop and exports average more than a billion dollars each year.

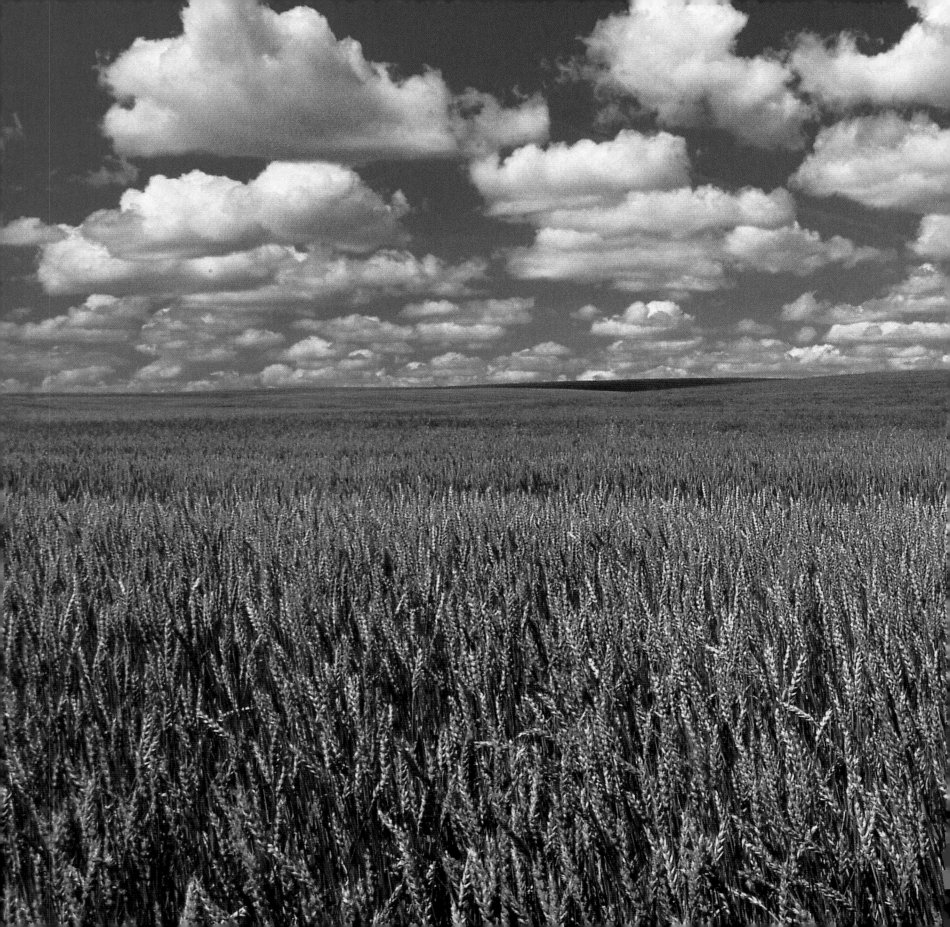

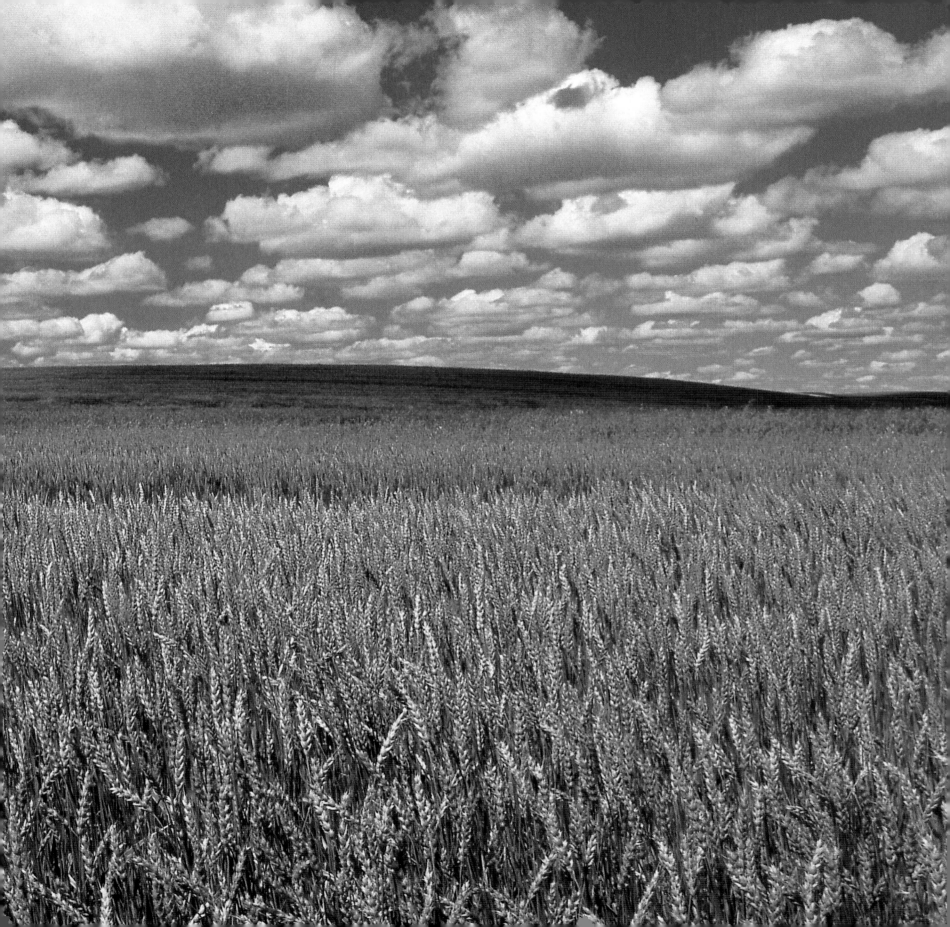

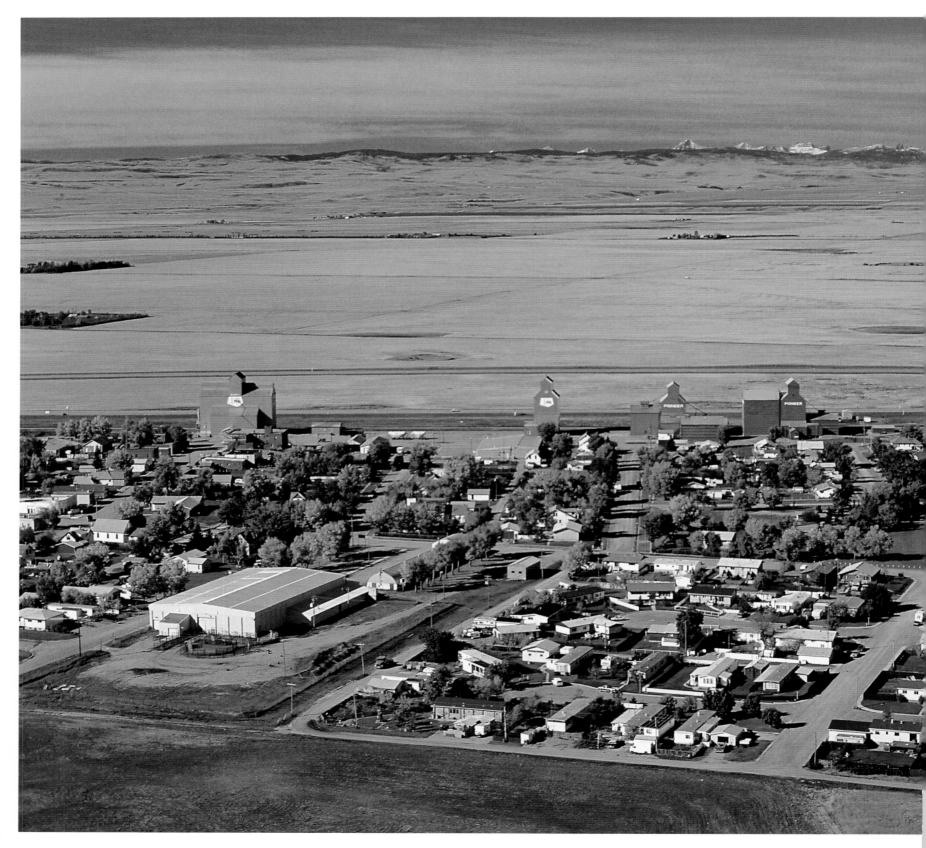

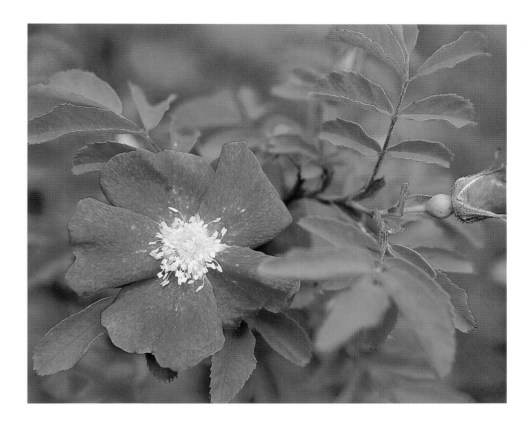

The wild rose, or prickly rose, blooms from June to August in clearings and along river and railway banks. In 1930, students chose the wild rose to be Alberta's official flower.

Although Alberta was settled by farmers, only 20 percent of the population continues to live in rural areas.

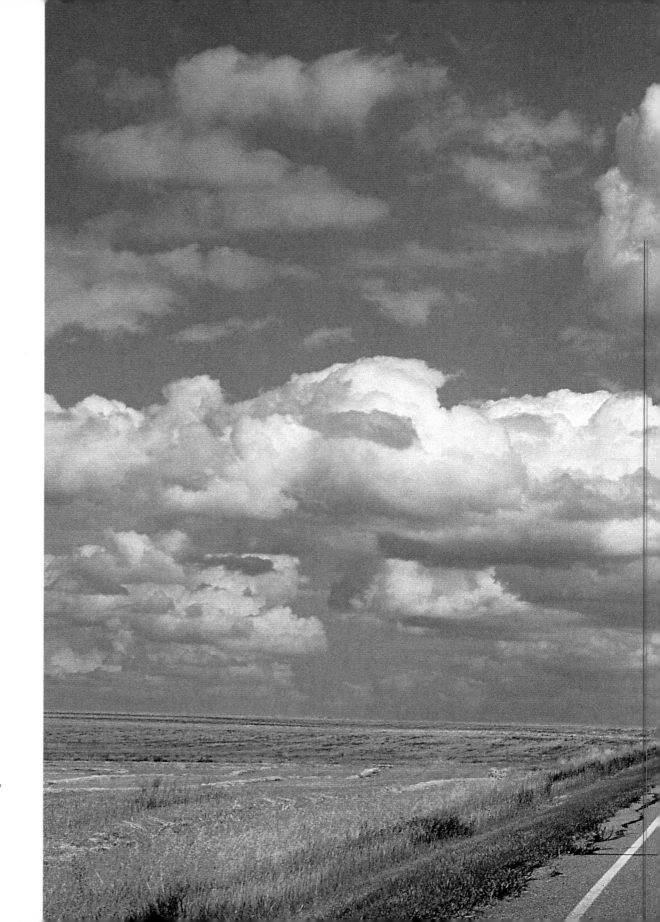

The unswerving line of the highway emphasizes the vastness of Alberta's prairie.

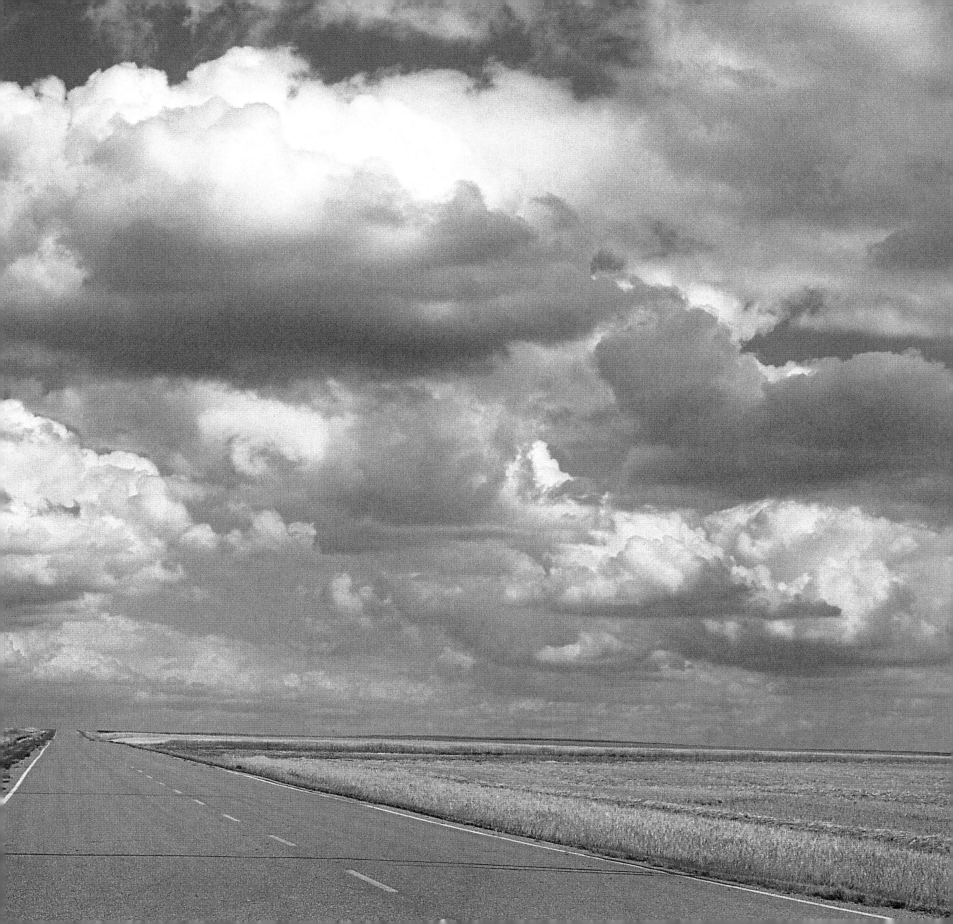

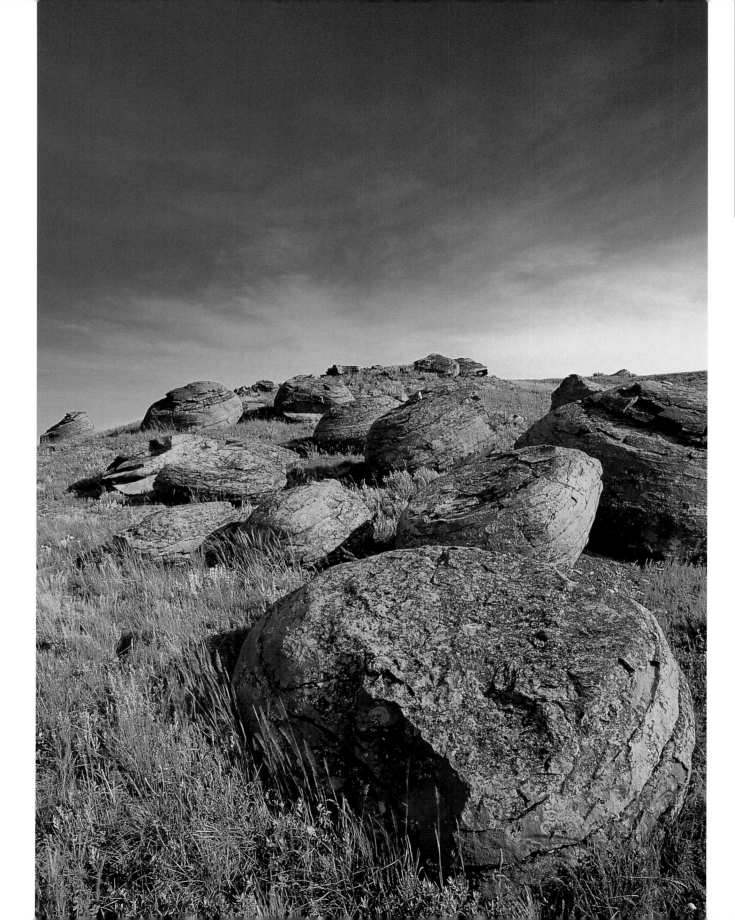

These sandstone boulders are slowly emerging from the earth, as the soil around them is blown away. They are part of the Red Rock Coulee Natural Area, about 25 kilometres south of Seven Persons.

The circular stone patterns of medicine wheels are still constructed and used by the Blackfoot First Nation. Traditionally, the sites have been used for spiritual rites and death ceremonies.

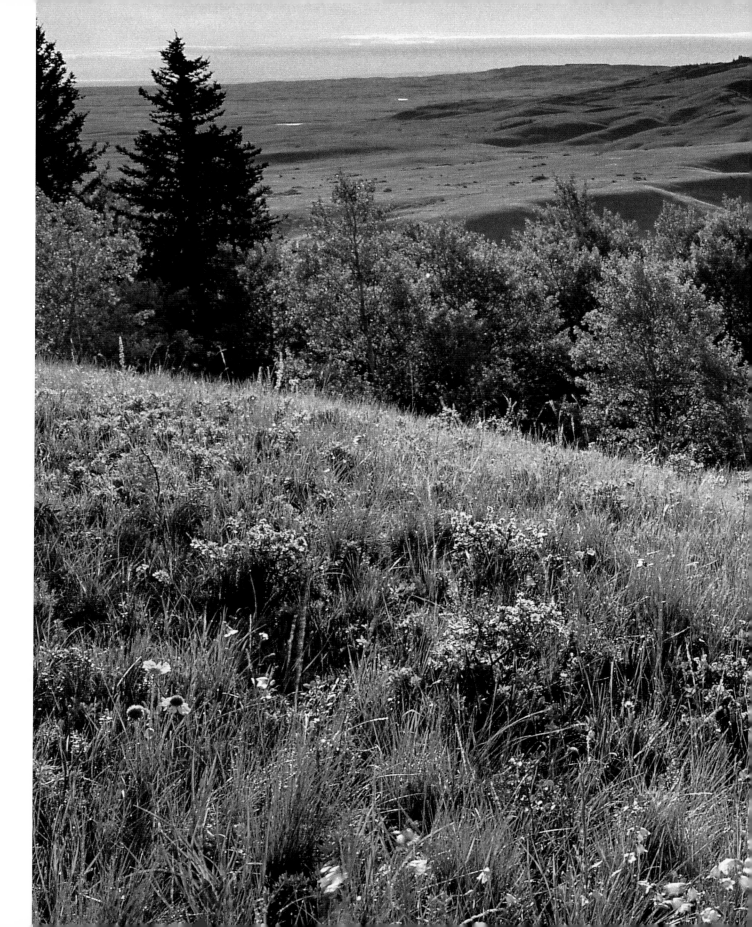

The Cypress Hills reach nearly 1,500 metres, the highest point in central Canada, and encompass a rich habitat much different from that of the surrounding plains. The woods and grasslands of Cypress Hills Provincial Park protect lynx, bobcat, coyotes, elk, beaver, and hundreds of bird species.

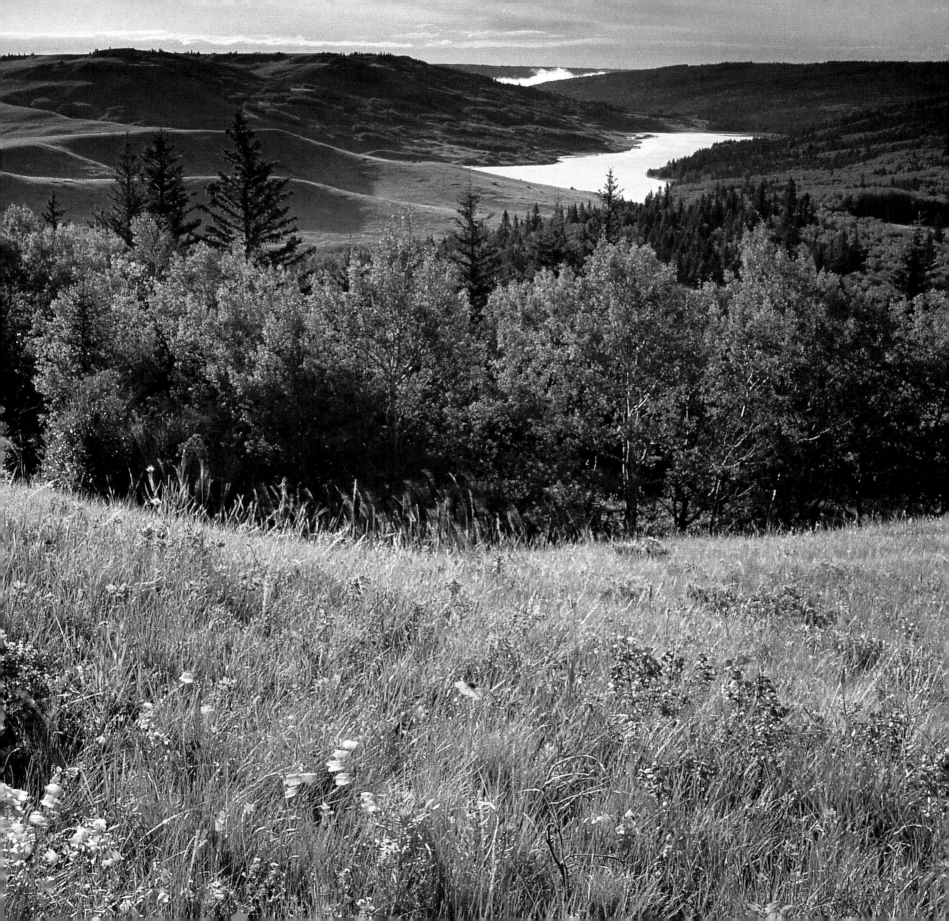

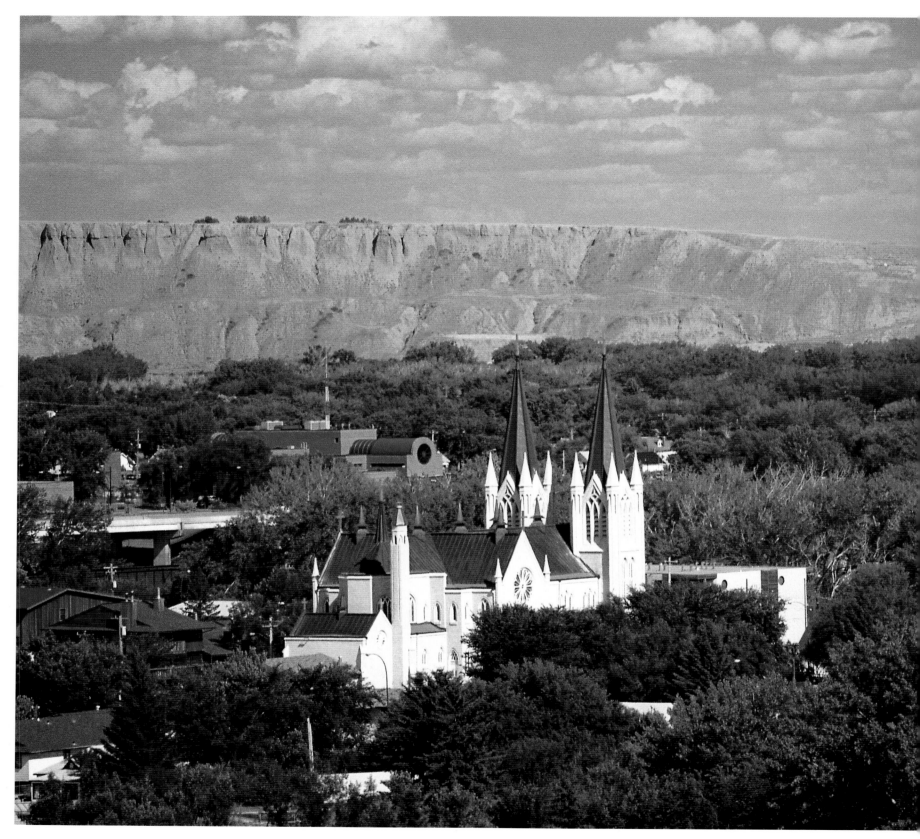

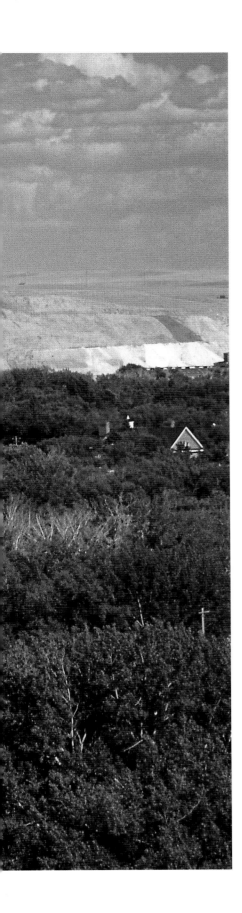

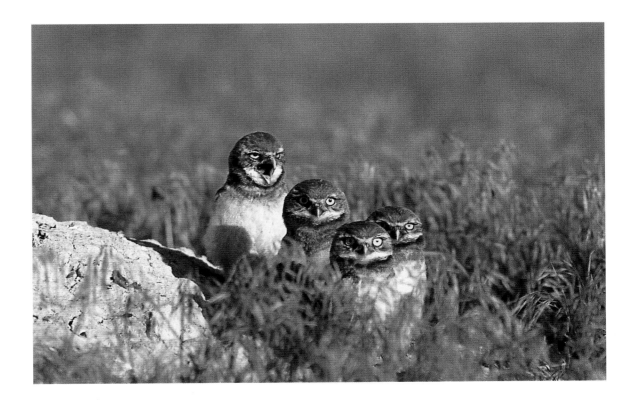

Burrowing owls live in the short grass prairie and nest in burrows dug by mammals. They usually hunt near dusk and dawn, but can sometimes be seen on summer days, when they must hunt more often to feed their young.

This picturesque view of Medicine Hat doesn't reveal what lies below the town. Vast underground reserves of natural gas caused Rudyard Kipling to proclaim that Medicine Hat had "all hell for a basement."

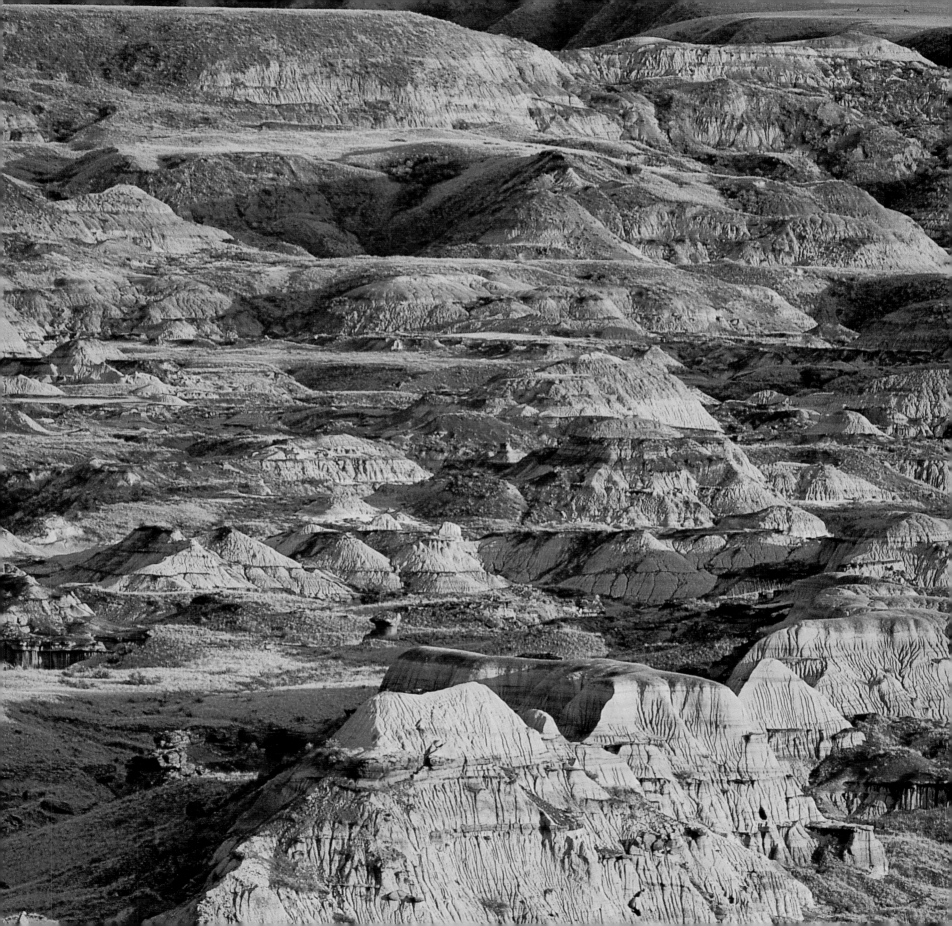

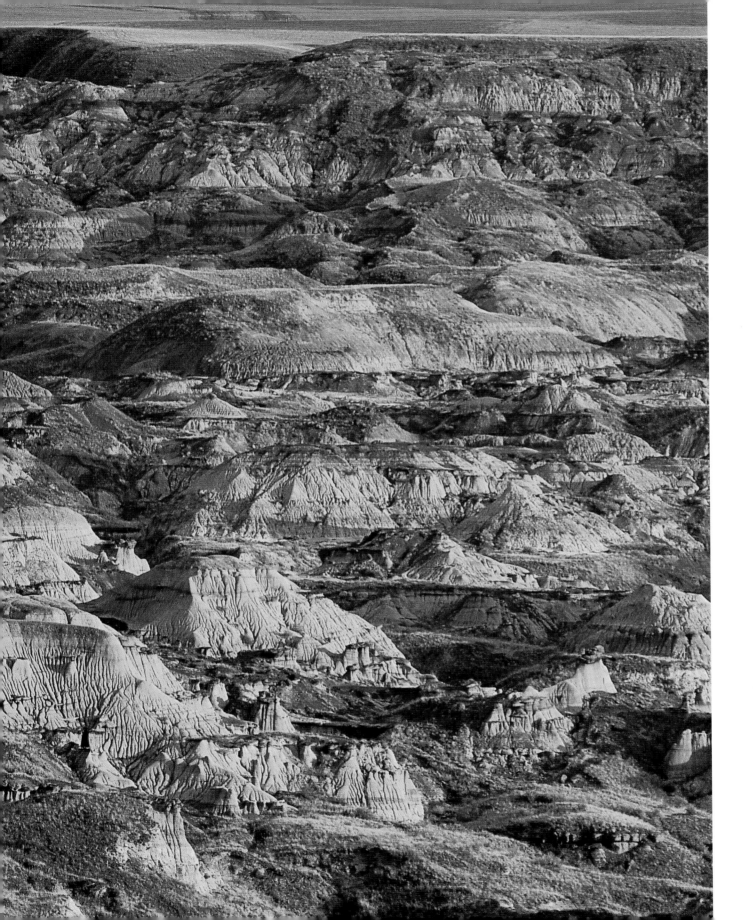

The other-worldly geography and rich fossil beds of the badlands have earned Dinosaur Provincial Park the status of a UNESCO World Heritage Site.

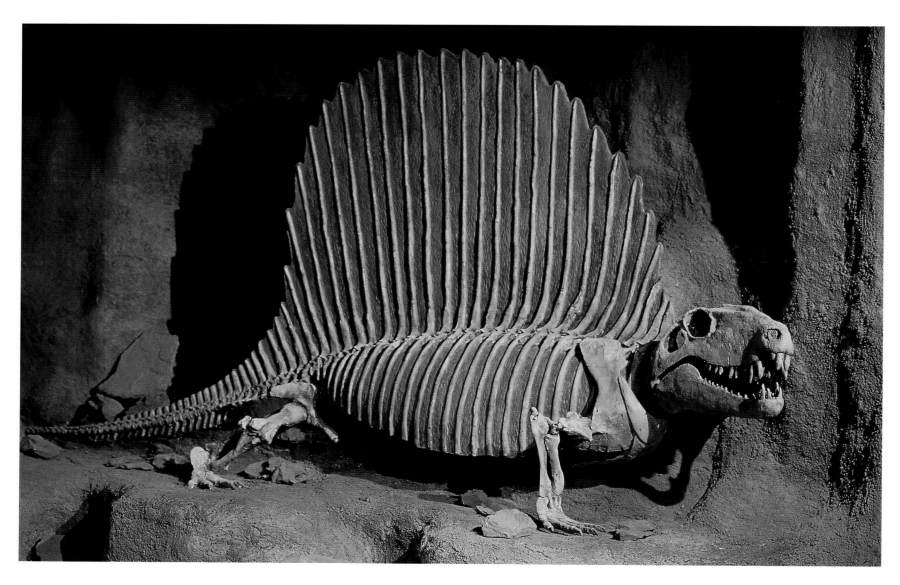

This dimetrodon is only a small part of the world's largest collection of dinosaur bones, on display at the Royal Tyrrell Museum of Palaeontology. Visitors view reconstructions of ancient Alberta, discover prehistoric plants, and watch palaeontologists at work.

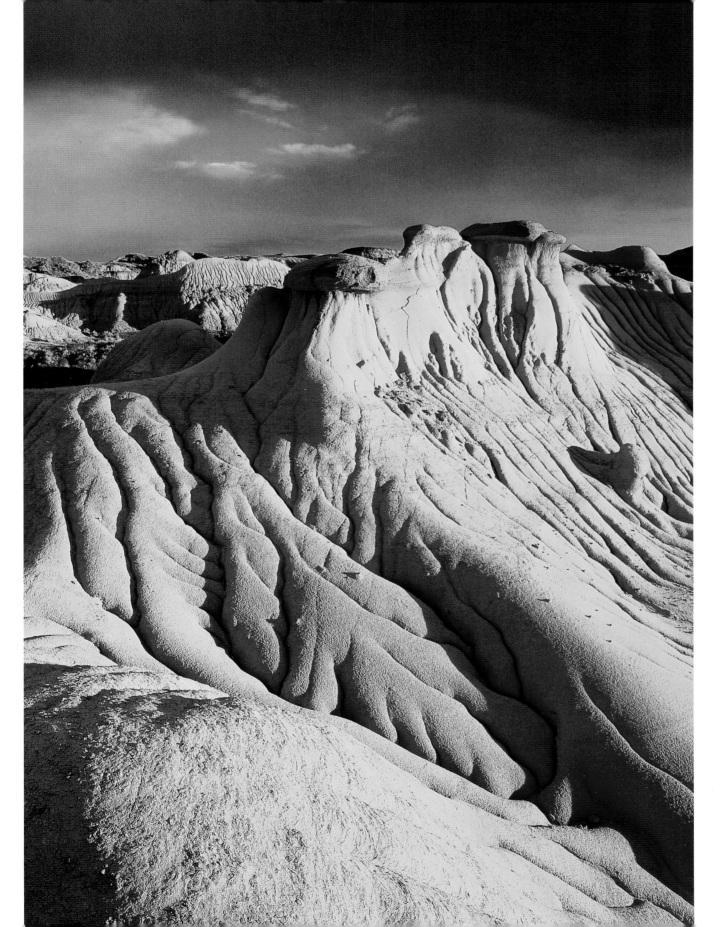

Dinosaurs roamed these badlands 75 million years ago. Archaeologists have unearthed the bones of more than 30 species—17 percent of the world's known dinosaur species—at Dinosaur Provincial Park. The area was much wetter in ancient times; the dinosaur skeletons share the land with crocodile and clam fossils.

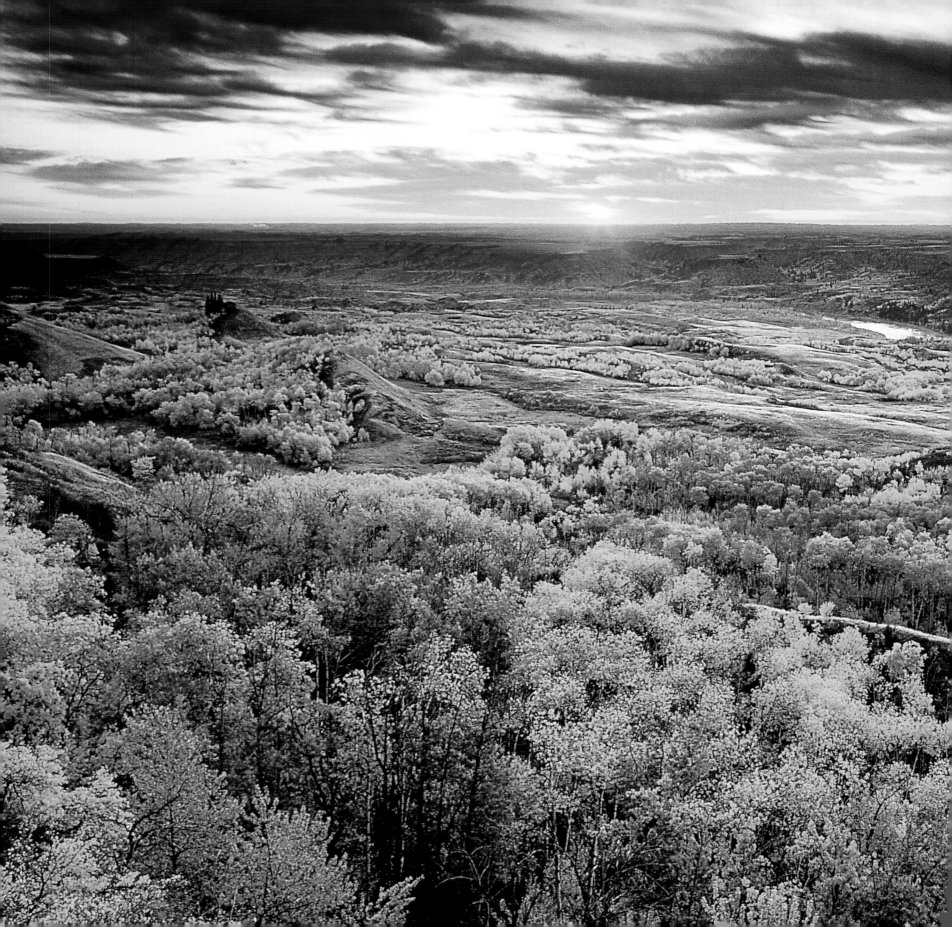

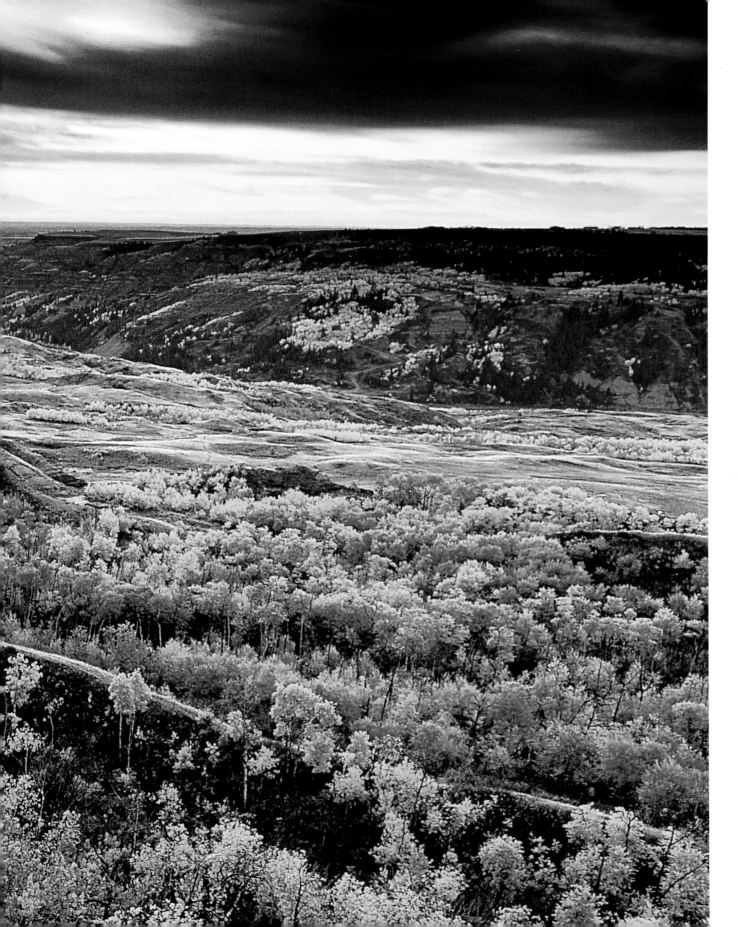

Buffalo jumps, such as the one at Dry Island Buffalo Jump Provincial Park, are almost invisible from ground level. Dry Island's high plateau was never surrounded by water—thus its unusual name.

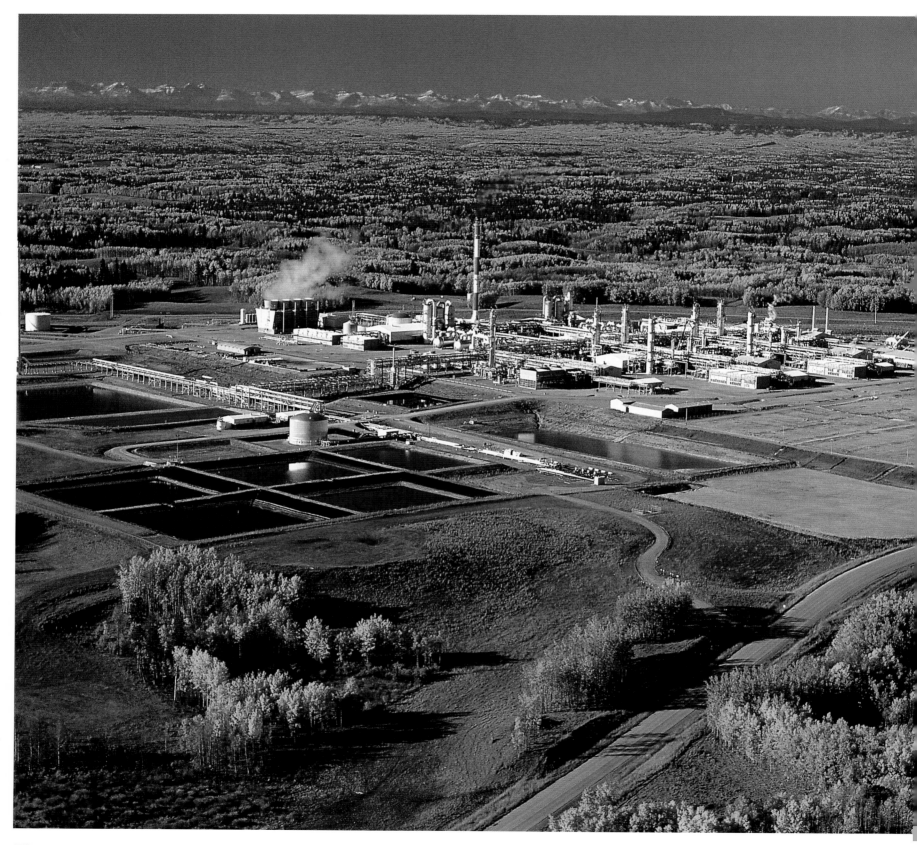

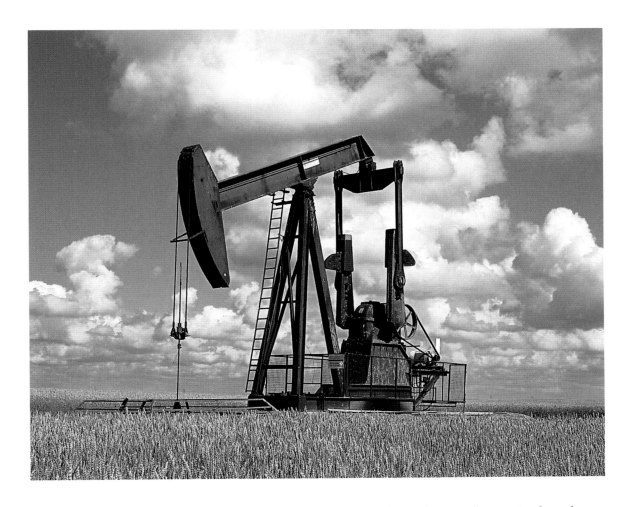

Oil pumps, often called donkey heads because of their shape, dot agricultural areas. Oil wells have been operating in Alberta for about a century and the province produces $10 billion worth of crude oil every year.

Much of the gas produced at plants like this one near the town of Caroline is exported to the United States.

Deep snow settles over the farmland near Leduc, just south of Edmonton.

FACING PAGE –
Albertans don't plant canola just for its eye-catching colour; annual export sales account for almost $700 million. The crop has a wide range of uses from cosmetics to medicine. There may even be canola in your fabric softener.

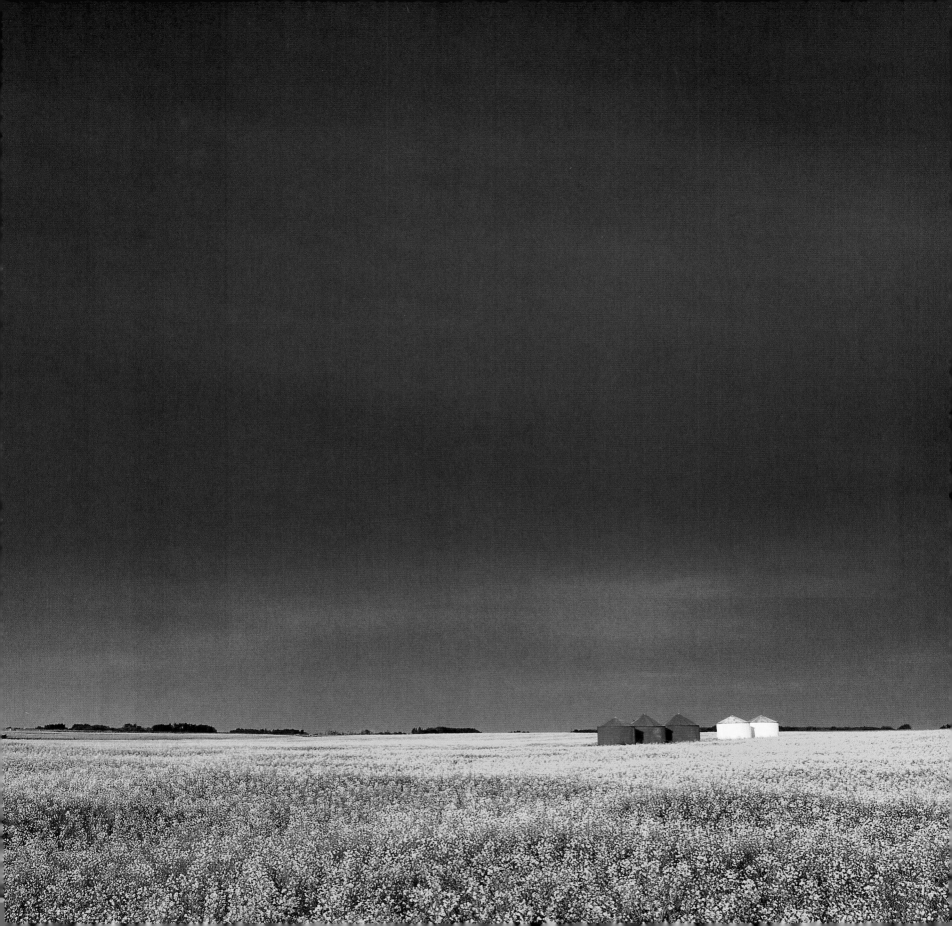

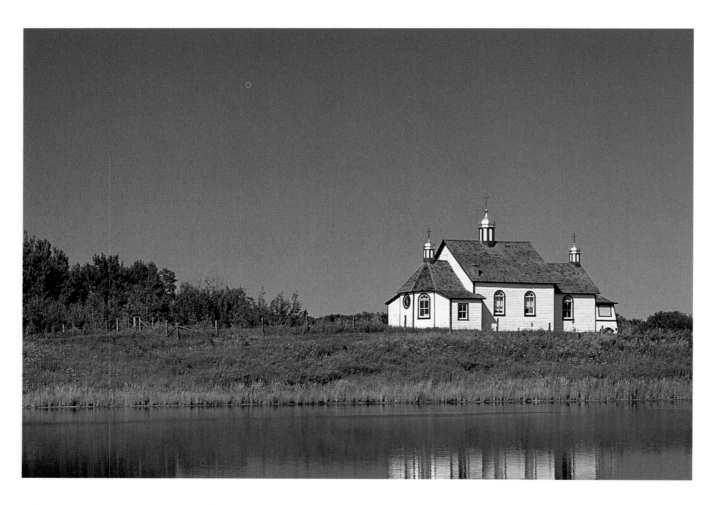

Ukrainian Canadians are Alberta's third-largest ethnic group. The Ukrainian Cultural Heritage Village east of Edmonton uses historic buildings, cultural performances, and a children's camp to teach visitors about the lifestyle of the earliest Ukrainian settlers.

OVERLEAF –
Fur-trading post, gateway to the gold rush, oil capital—Edmonton has undergone many transformations since it was founded by the Hudson's Bay Company in 1795.

Alberta is known for its continually changing weather. A warm chinook can sweep away winter temperatures in a matter of hours, and spring storms like this one can turn a sunny day into a swirl of clouds.

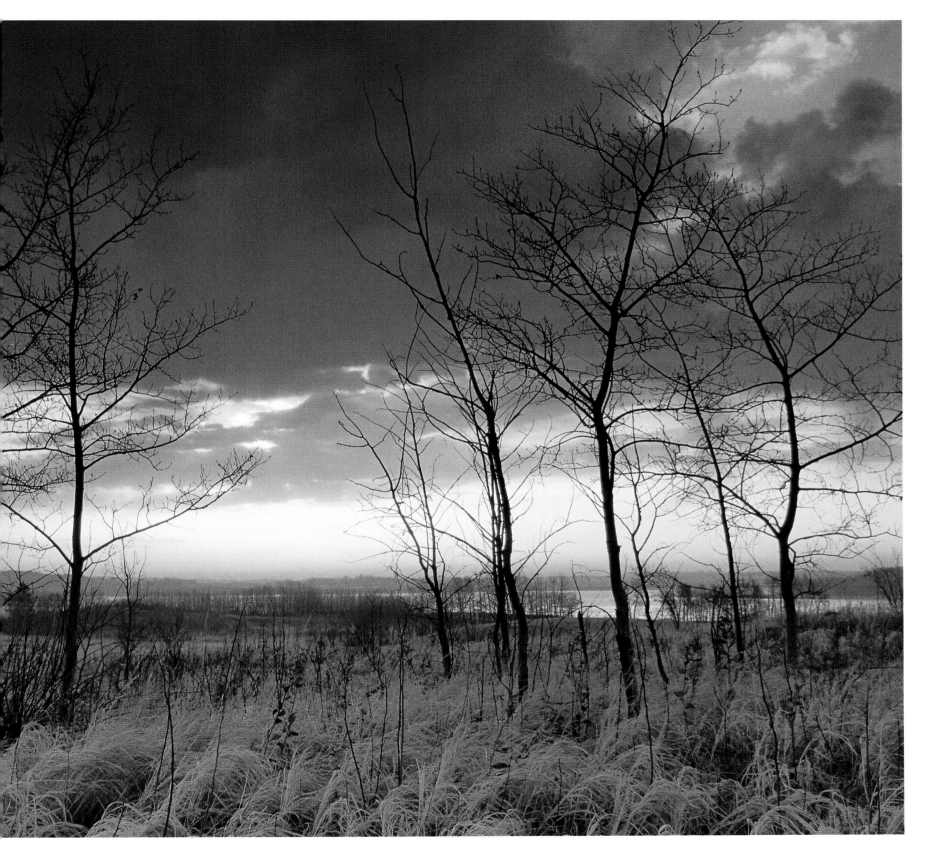

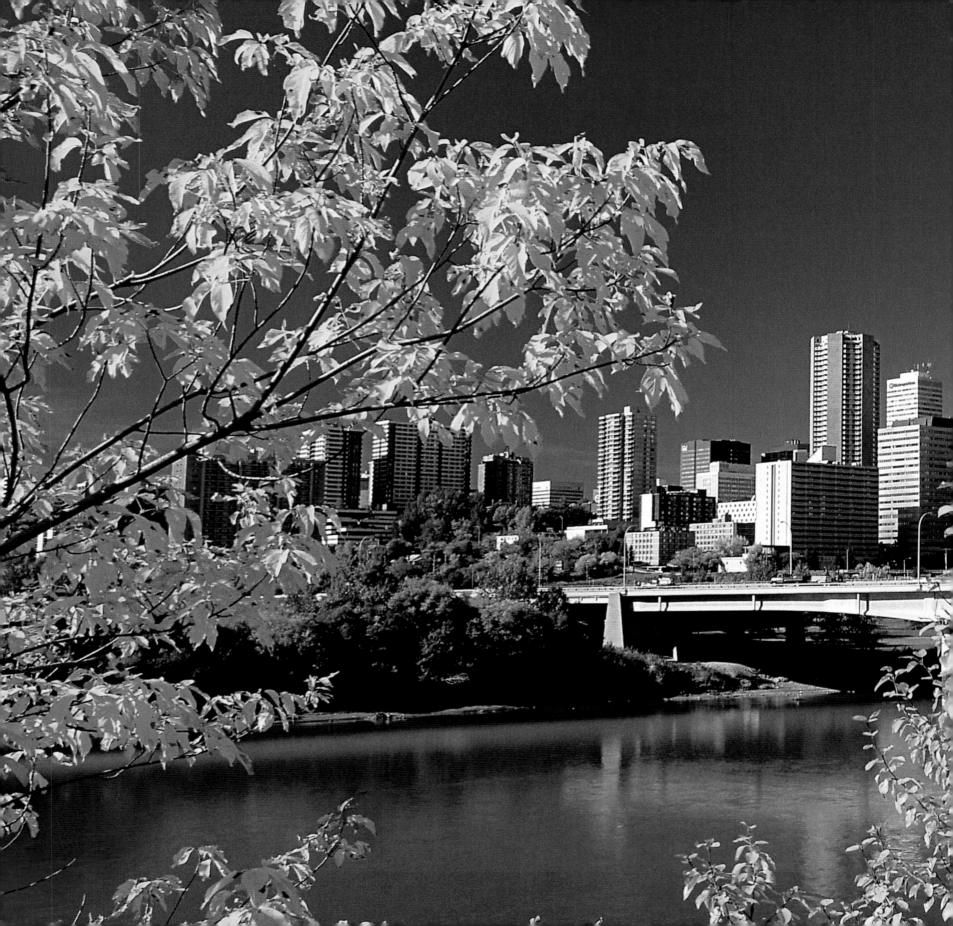

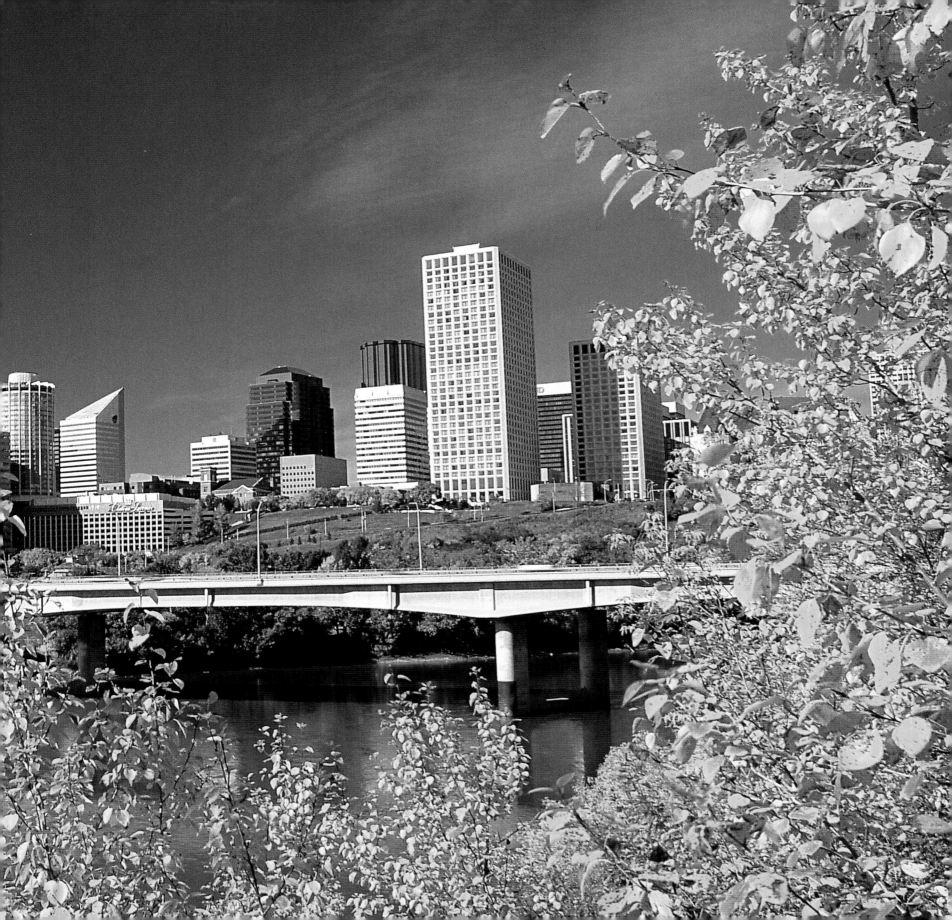

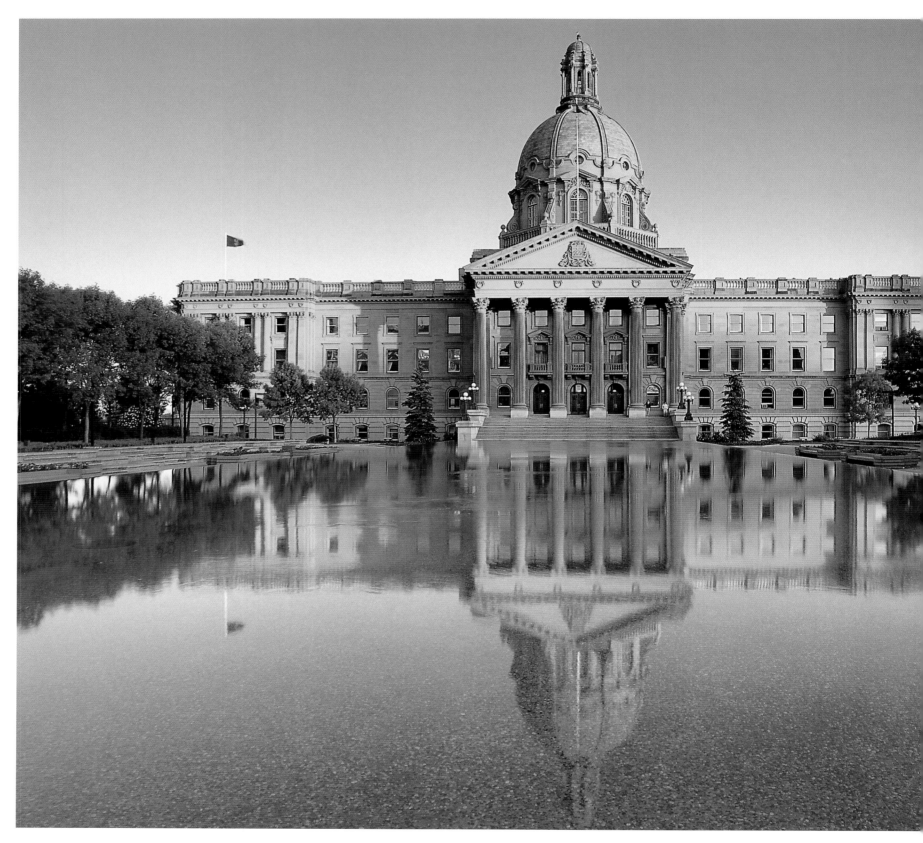

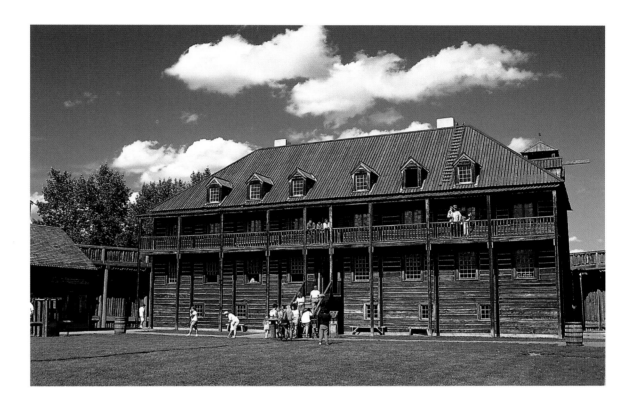

Fort Edmonton Park re-creates the city's history, as a nineteenth-century fur-trading fort and an early twentieth-century city.

The Legislature was completed in 1912 on the site of one of Edmonton's original fur-trading posts.

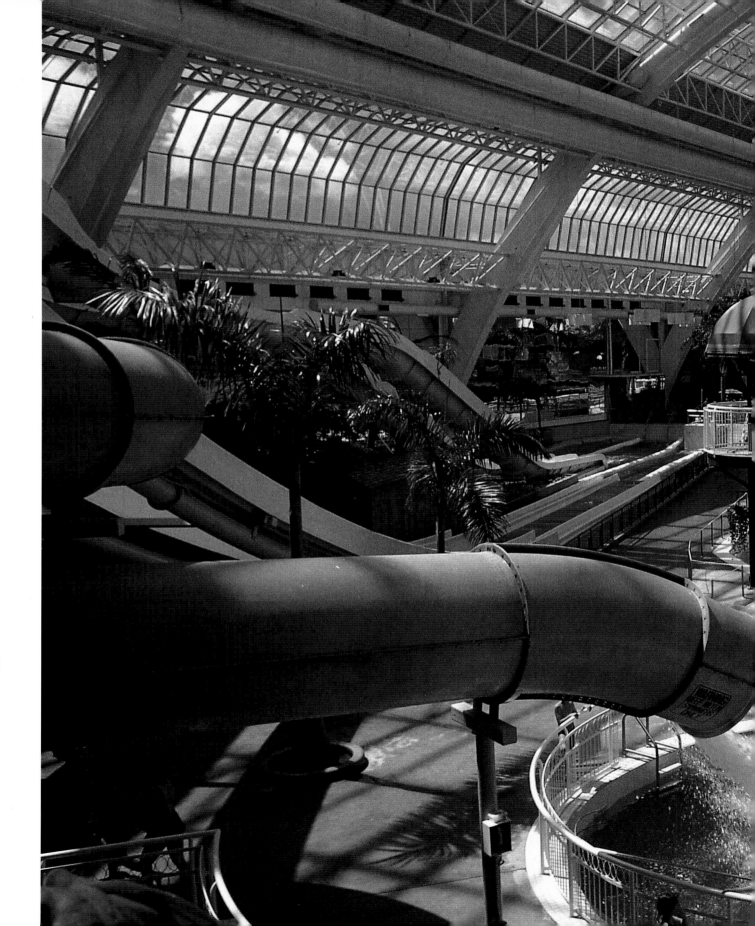

With 800 stores, an amusement park, waterslides, an indoor lake, a skating rink, and a miniature golf course, the West Edmonton Mall is the city's biggest tourist attraction and the largest shopping centre in the world.

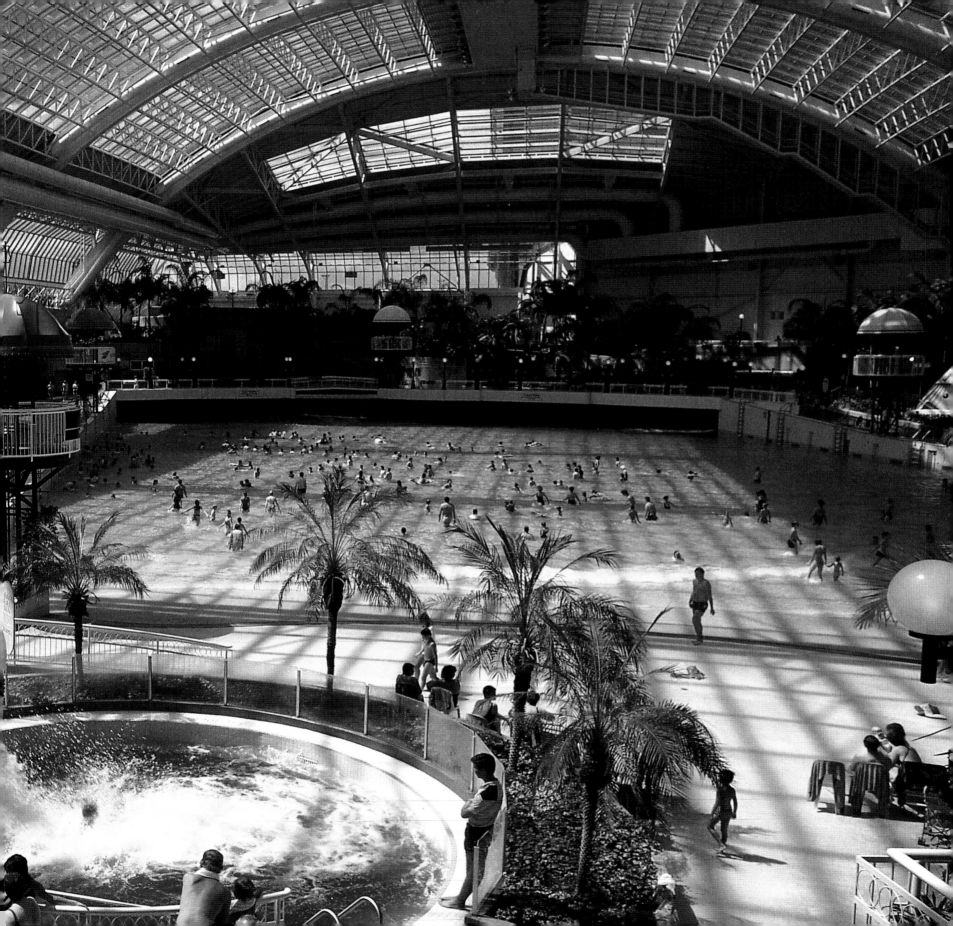

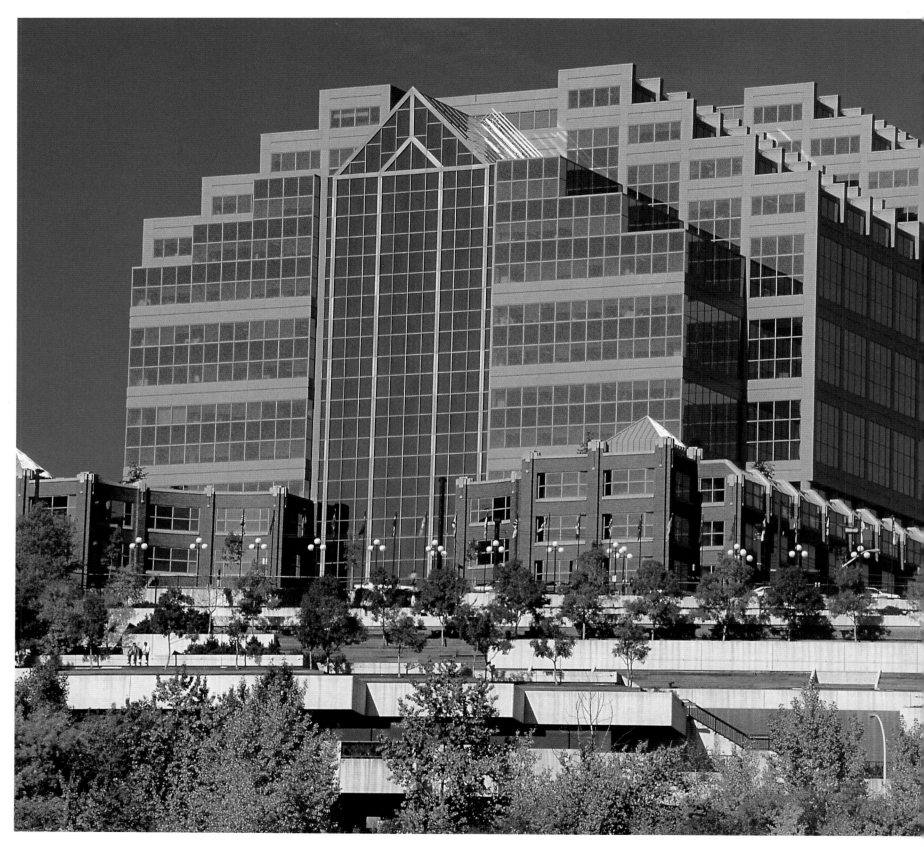

82

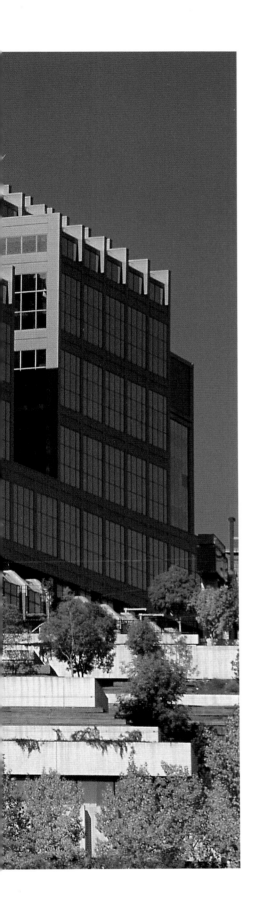

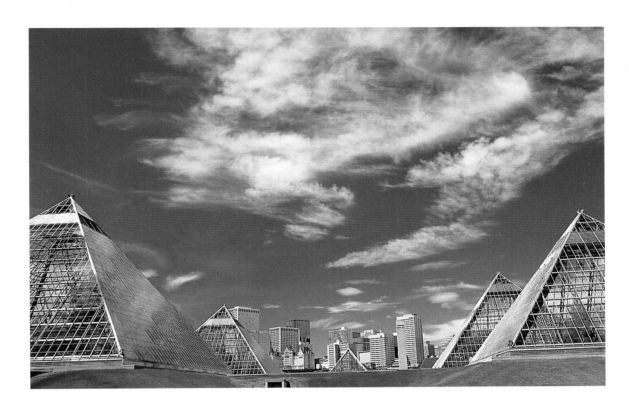

The unique greenhouses of the Muttart Conservatory replicate tropical, temperate, and arid climates.

The Edmonton Convention Centre is built into the hillside. Through its numerous glass walls, visitors enjoy a panoramic view of the North Saskatchewan River Valley.

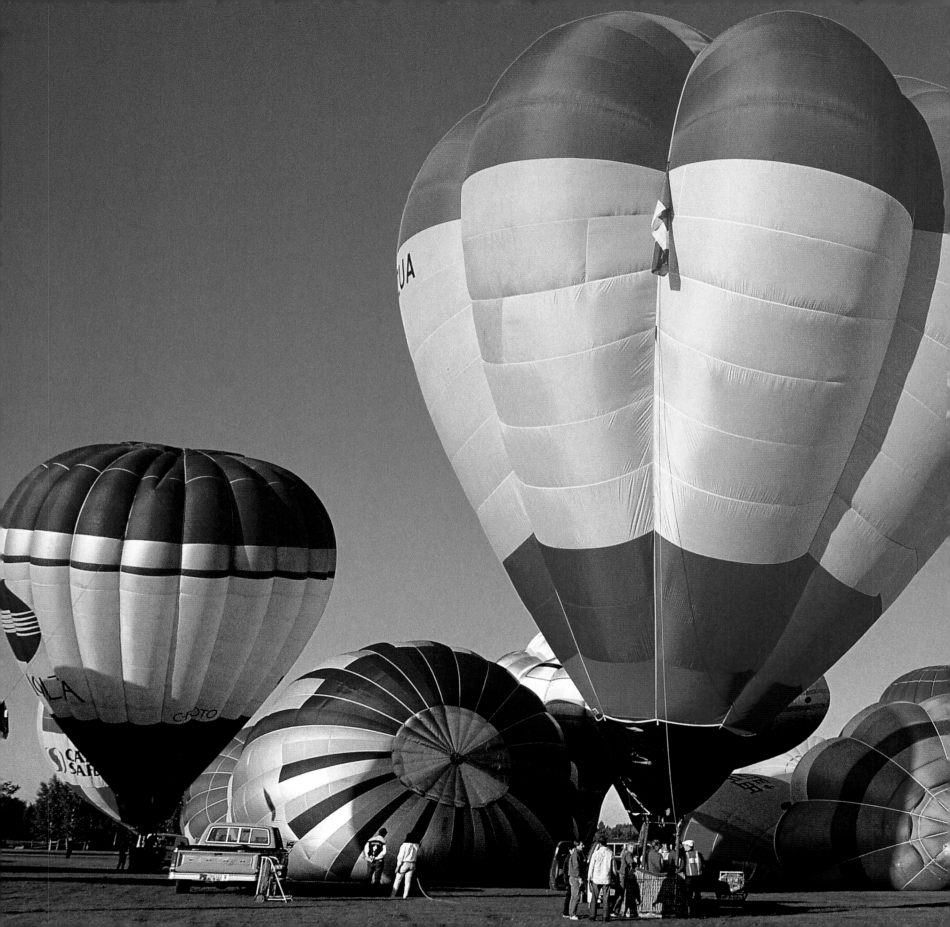

Long summer days are perfect for balloon rides. This sport is popular across the province and several communities hold hot-air balloon festivals.

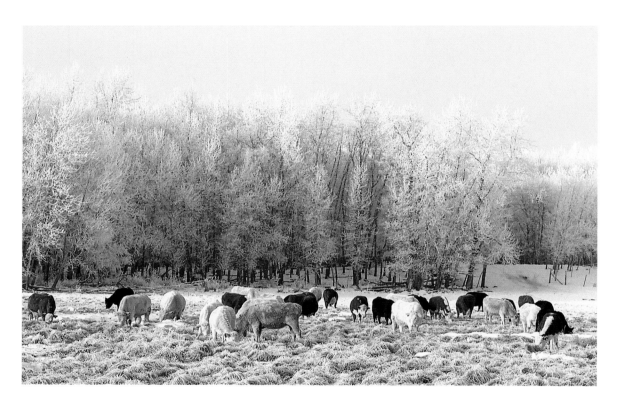

Stony Plain, west of Edmonton, has been an agricultural community since the turn of the century.

The land around Tofield, just east of Edmonton, offers refuge to more than 250 bird species. Some stay year round, but many, including hawks, bald eagles, and falcons, winter farther south and return in early spring.

OVERLEAF –
A lone canoeist enjoys the serenity of Astotin Lake in Elk Island National Park. The government established the park in 1913 to protect elk from overhunting.

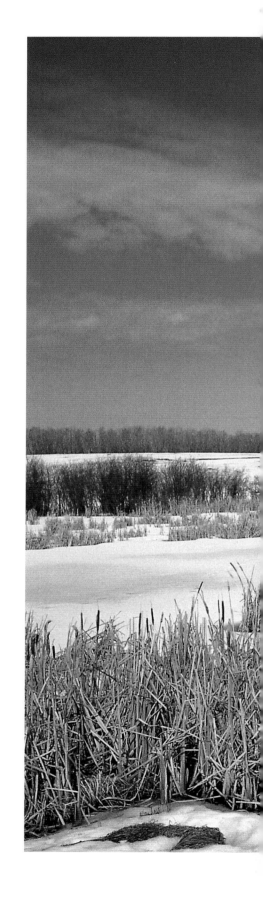

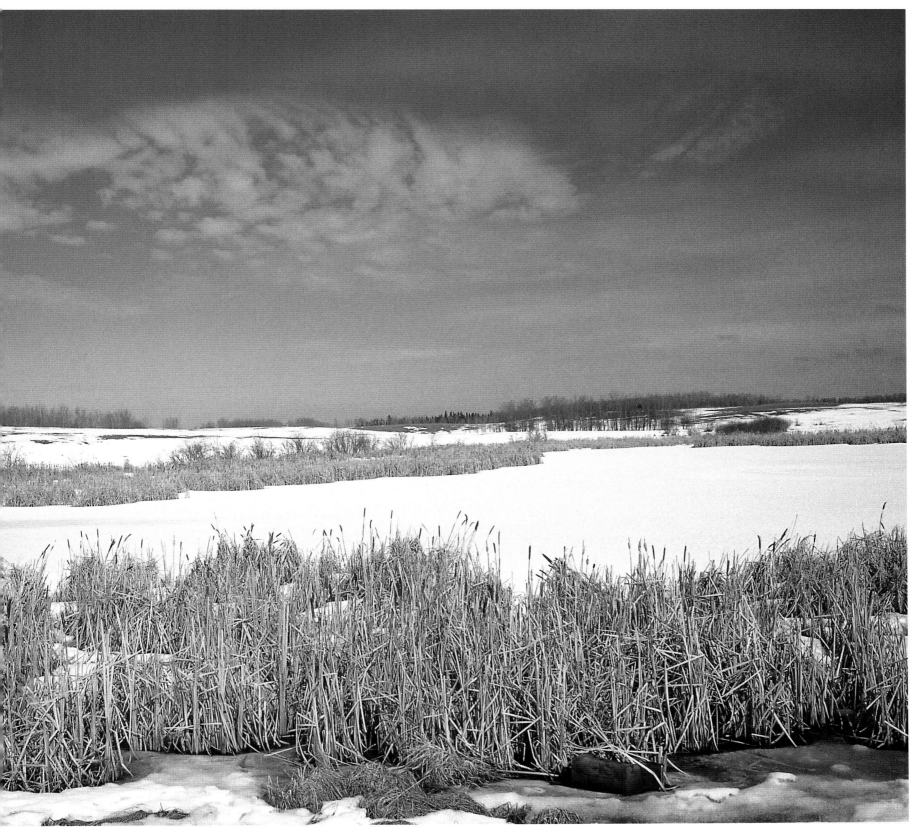

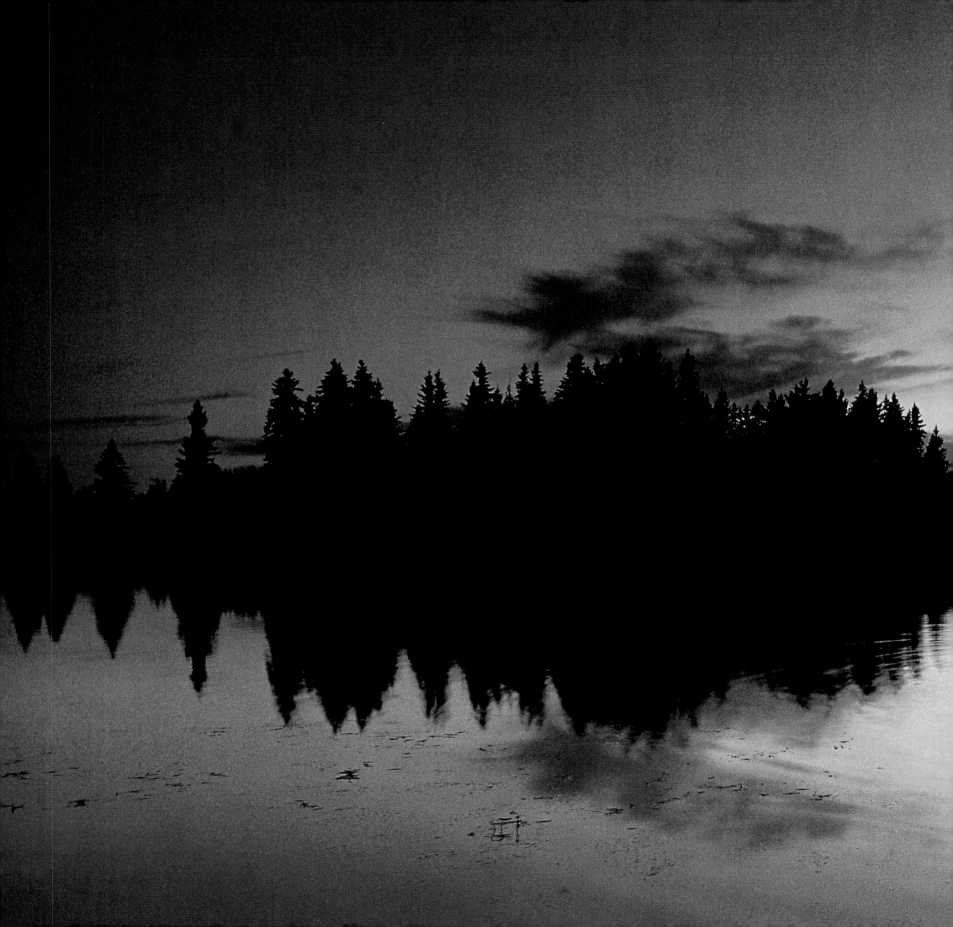

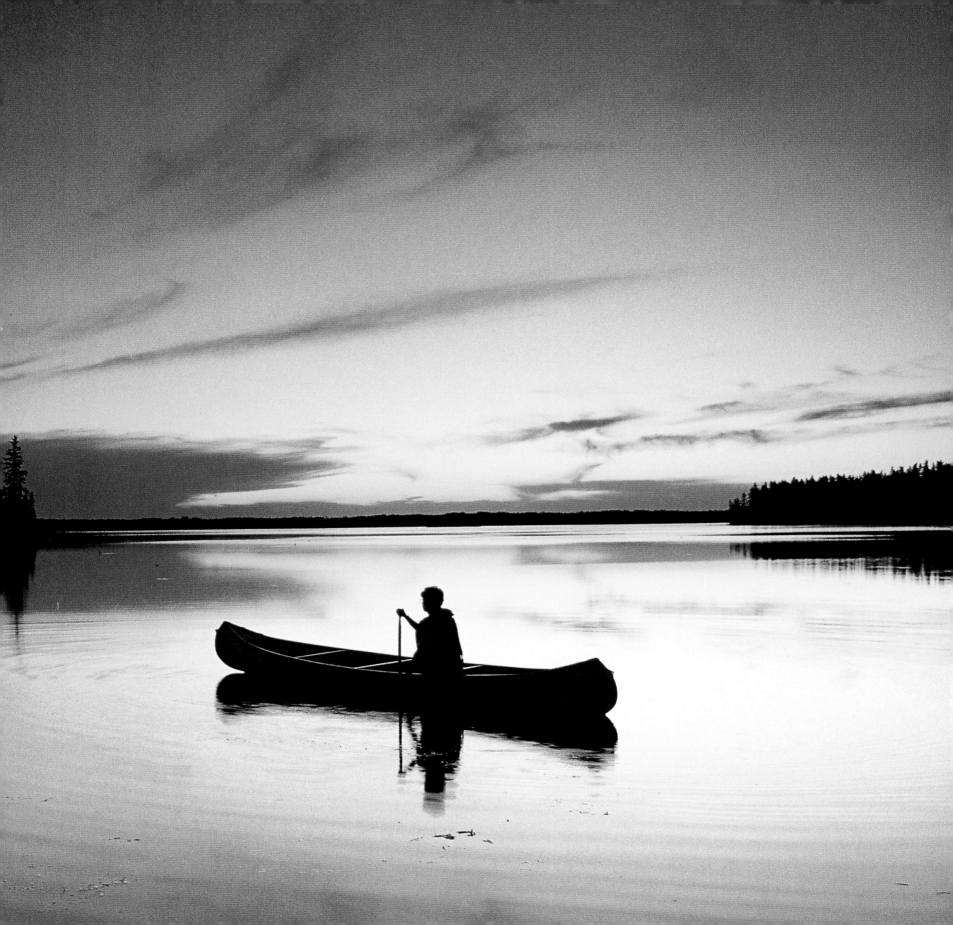

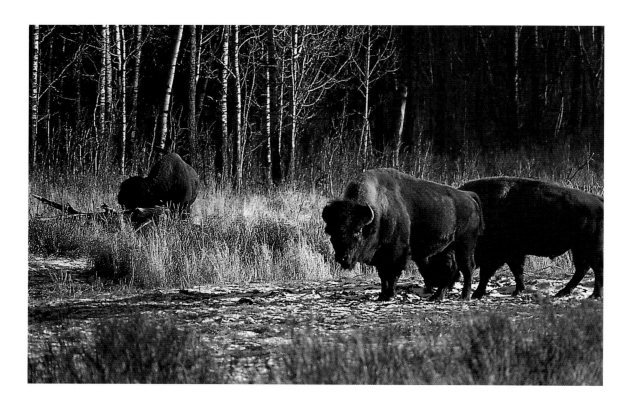

Hunting almost drove the bison to extinction, but with government protection the population is slowly increasing. These plains bison are part of a herd of about 700 animals within Elk Island National Park. The park is also home to a herd of wood bison, the largest land animals in North America.

One of Alberta's best fishing lakes, Lesser Slave Lake, lies two hours northwest of Edmonton. During the Klondike Gold Rush, this area was a stopover on the trail from Edmonton to Dawson City, Yukon.

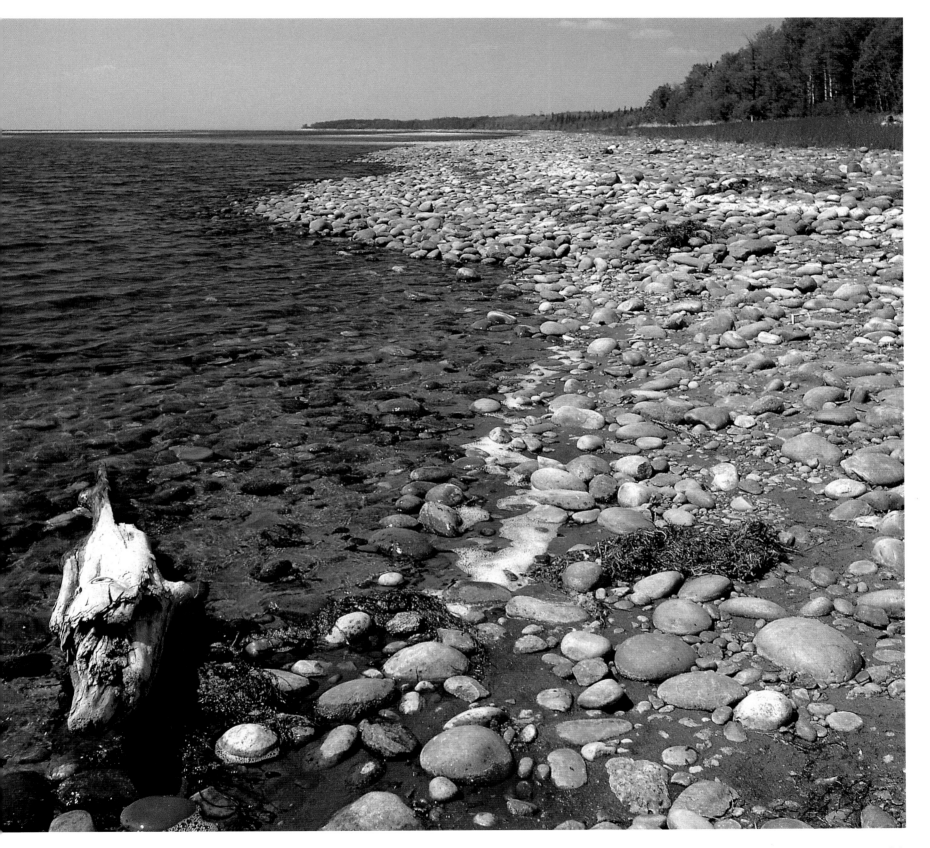

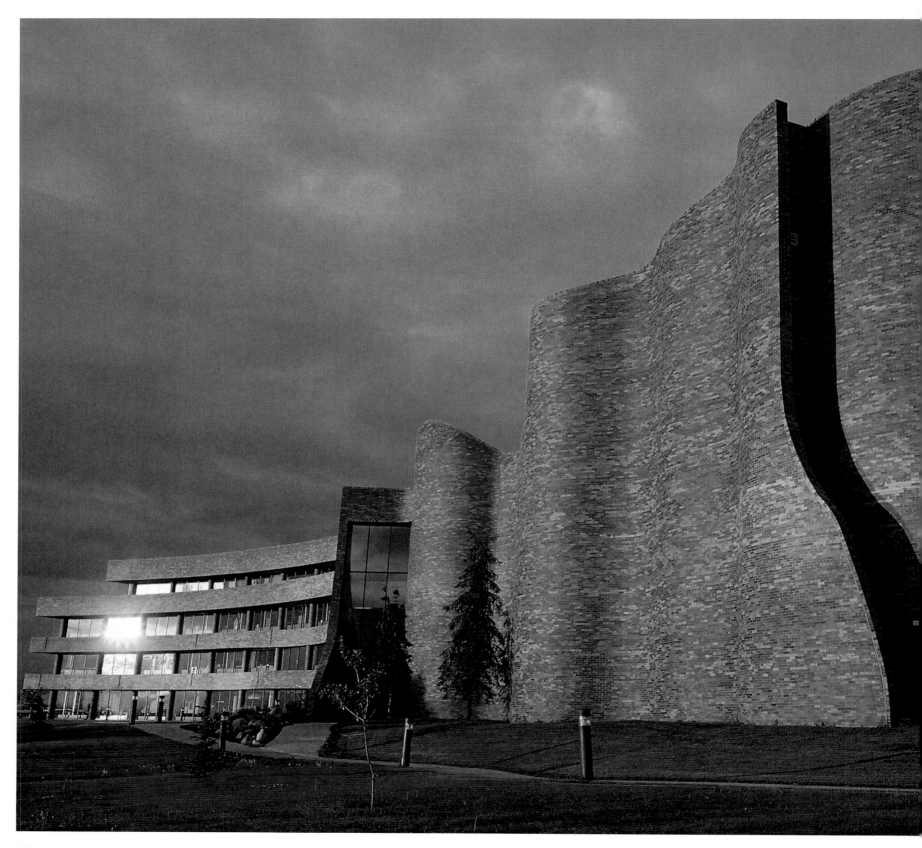

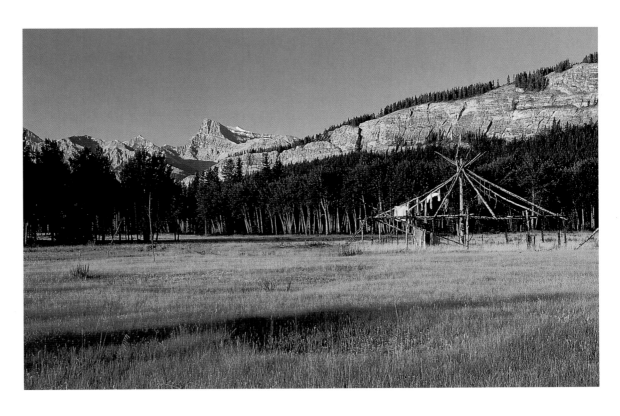

The Kootenay Plains west of Rocky Mountain House are the traditional site of the Stoney First Nation's sun dances.

The distinctive Grande Prairie College was designed by architect Douglas Cardinal, who also created the Museum of Civilization in Hull, Quebec. The college opened in 1966 and now serves about 1,600 full-time students.

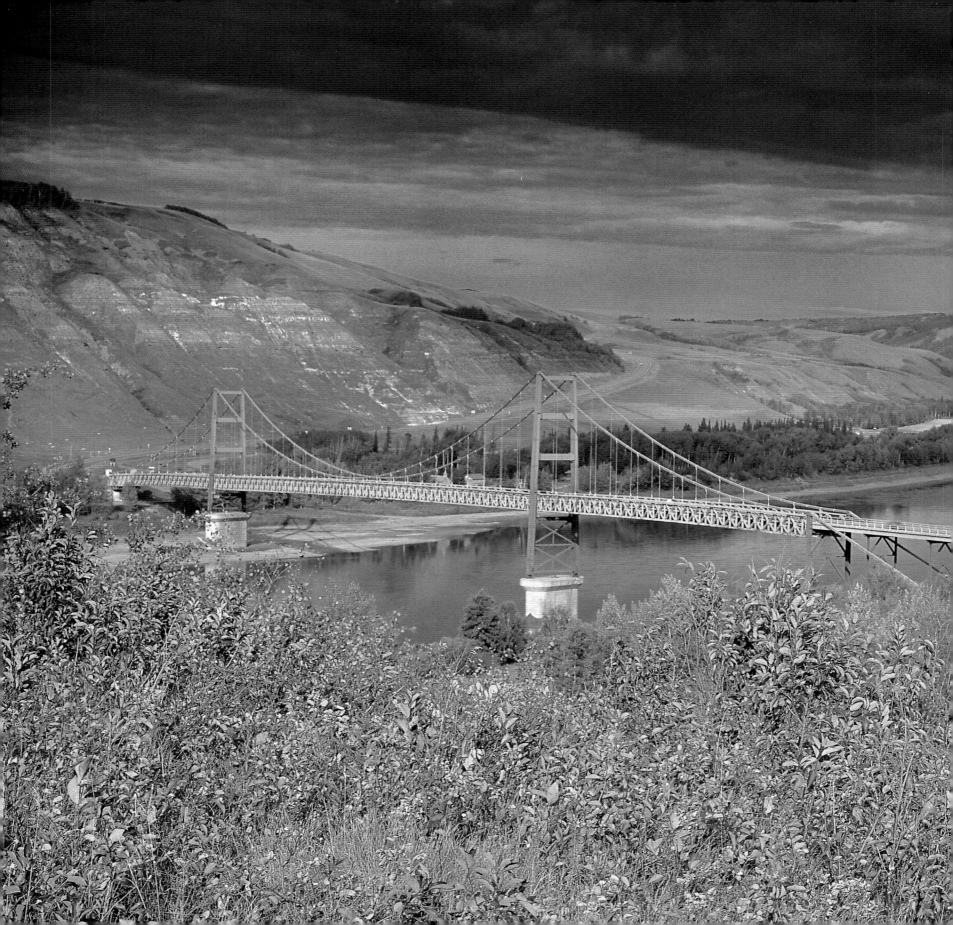

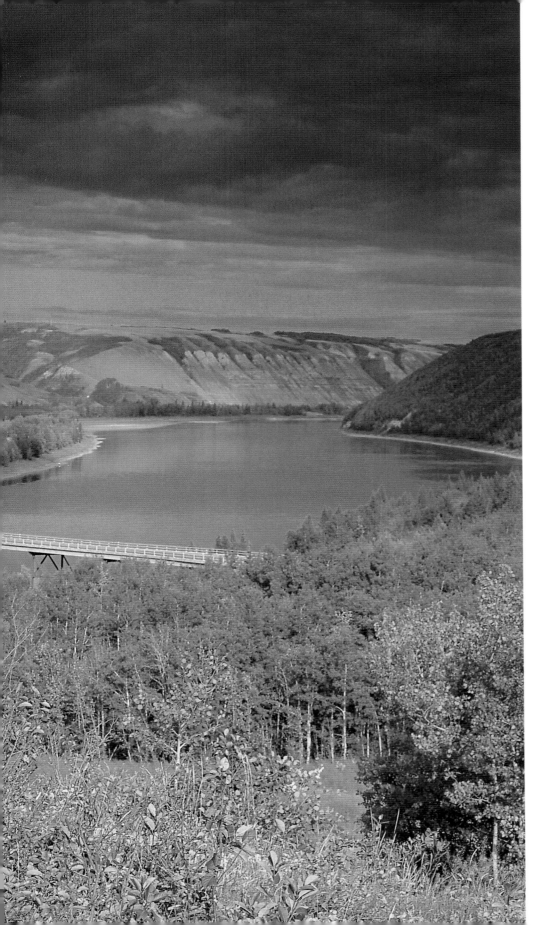

Spanning the Peace River, the Dunvegan Suspension Bridge is Canada's fourth-longest suspension bridge.

Photo Credits